THE COMPLETE
COLORED
PENCIL
BOOK

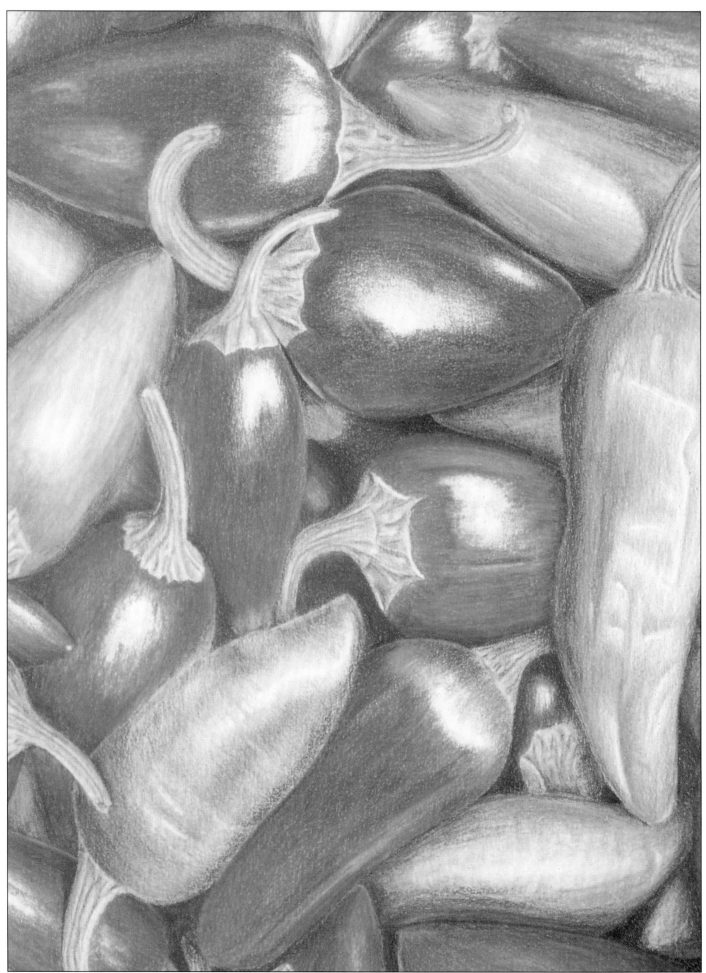

CHILI PEPPERS, Gary Greene

THE COMPLETE
COLORED
PENCIL
BOOK

BERNARD POULIN

NORTH LIGHT BOOKS

CINCINNATI, OHIO

The successful completion of this book is due
in large measure to the dedicated persistence,
professional savvy, and *patience* of my editors,
Greg Albert and Rachel Wolf.

I also would like to extend my sincerest thanks
to all the arists whose beautiful work enhances
the visual quality of this book.

To the Colored Pencil Society of America and
especially Vera Curnow, its founder, I extend
my most heartfelt appreciation for the invaluable
and generous assistance accorded me in the
culling of ideas for this book.

Finally, I would like to acknowledge my wife
and daughters who, despite the fact they have
neither seen nor heard from me since I entered the
studio a year or so ago to complete this book, still
recognize me as husband and father.

The Complete Colored Pencil Book

Copyright © 1992 by Bernard Poulin. Colored pencil drawings and
other art copyright © 1992 by various artists where credited. Printed
and bound in China. All rights reserved. No part of this book may
be reproduced in any form or by any electronic or mechanical means
including information storage and retrieval systems without
permission in writing from the publisher, except by a reviewer, who
may quote brief passages in a review. Published by North Light
Books, an imprint of F&W Publications, Inc., 1507 Dana Avenue,
Cincinnati, Ohio 45207. (800) 289-0963. First edition.

Other fine North Light Books are available at your local bookstore,
art supply store or direct from the publisher.

02 01 00 99 98 11 10 9 8 7

Library of Congress Cataloging-in-Publication Data

Poulin, Bernard
The complete colored pencil book / by Bernard Poulin.
 p. cm.
Includes index.
ISBN 0-89134-418-7
1. Colored pencils. 2. Colored pencil drawing. I. Title.
NC892.P68 1992
741.2′4—dc20 91-36388
 CIP

Edited by Greg Albert and Rachel Wolf
Designed by Clare Finney

To my mother and father,
whose encouragement
still guides my hand.

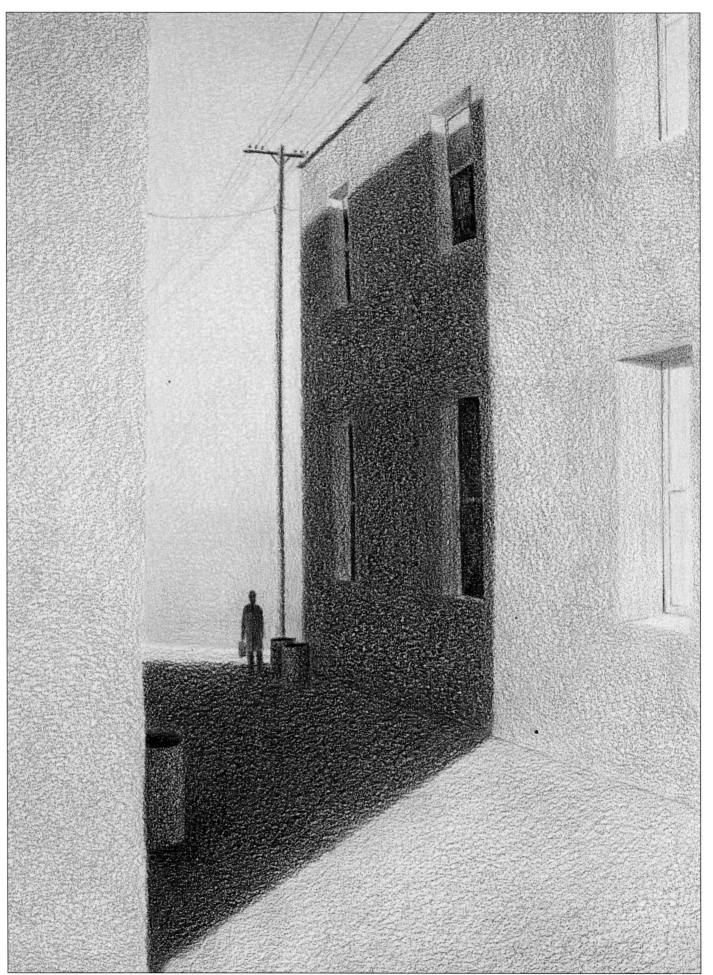

ALLEY MEDITATIONS, Allan Servoss

CONTENTS

INTRODUCTION

One of the most consistent tools of expression for each of us has been the colored pencil. The day we received our first full box of assorted colors we felt grown-up, the passage from baby status to childhood was complete. The broken wax crayon stubbles were immediately thrown out to make way for the more elegant, and "mature," pencils.

As time passed, their allure faded, too. These colored pencils were often the cheaper kinds, sporting hard leads and producing color that lacked the brilliance sought by our vivid imaginations. Despite their capacity for more exact line renderings, the emotional impact of the hues they imparted left much to be desired. Eventually, school introduced us to watercolors, which seemed to meet our undefined creative needs.

Towards adolescence (if not yet artistically discouraged), oil paints with their "buttery" sophistication pulled us away from the "immaturity" of pencils and watercolors. Working with oils was the sign of a "real" artist! We had finally reached, or so we thought, the most commonly accepted medium of professional stature.

Because childhood years are seen as lacking in maturity and sophistication, art tools used by children also are seen as unworthy of adult consideration. It is therefore difficult for us to separate "materials" from the process of "maturity." We have been conditioned to view some art materials as infantile and others as adult.

Luckily, people who enjoy art do not adhere to such limited viewpoints. In the search for materials that will help us convey accurately our visions and perceptions, we often return to those tools with which we were most comfortable in childhood.

Great paintings have been produced in watercolor by some of the world's finest artists, yet the "value" of these renderings has traditionally been considered to be less than those created in oils. Today, however, watercolor is beginning to get the recognition it deserves. Likewise, the colored pencil, in the past used primarily by designers and illustrators, is slowly being acknowledged as a valid tool of expression in the fine arts arena.

In presenting *The Complete Colored Pencil Book*, I wish to offer every reader a glimpse into the world of a versatile and vibrant medium, one that hopefully brings back fond "childlike" memories. At best, I hope the rediscovery of colored pencils will be an inspiring one. Colored pencils have evolved greatly. The spontaneous application of rich, deep colors will certainly enthrall those of you who find the combination of drawing and painting an exciting exercise.

Bernard Aime Poulin, author

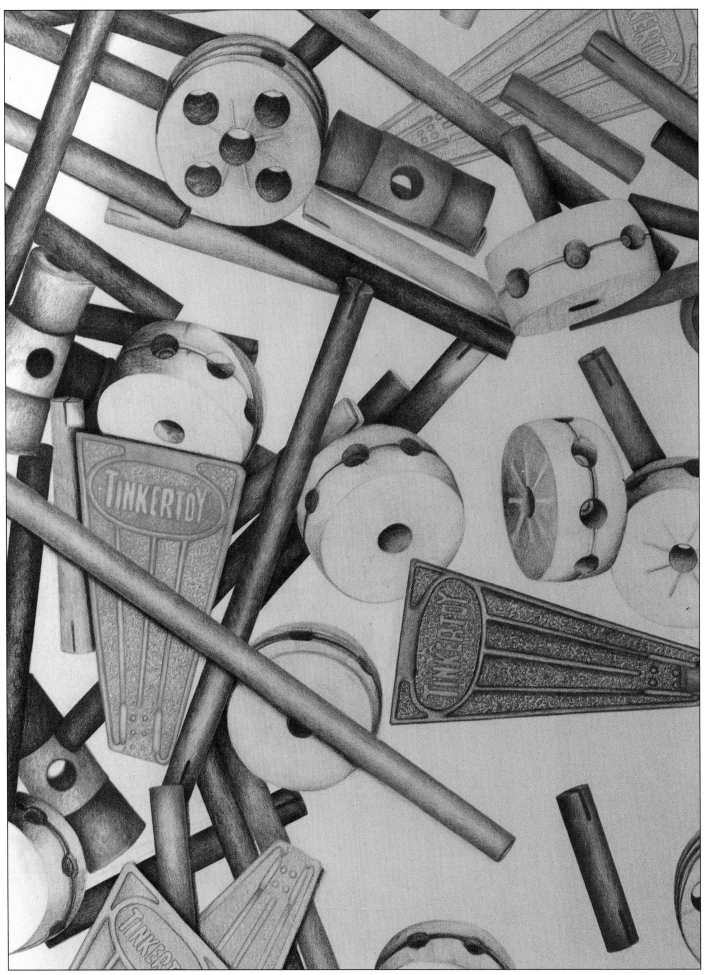

DRAWING TOOLS

TINKER TOYS
Christine Fusco

The *Complete Colored Pencil Book* was written to take you beyond those first hatches and crosshatches that piqued your interest in colored pencil artwork.

Though you may be a relative newcomer to colored pencils, you will be surprised at how exciting it is to extend your basic experiences into more elaborate and satisfying renditions.

But before crossing the next hatch in this adventure with colored pencils, take time to analyze the techniques and styles you generally practice. First, examine the tools you use.

Like other mediums, colored pencils should be selected to suit your specific needs. The differing qualities of these carefully manufactured pencils will be explained in this chapter. Not all colored pencils are created for the purpose of fine artwork; some are produced for illustration or graphic art rendering.

It is important to know whether you enjoy producing graphically precise drawings, fluid-stroked fine art renderings or illustrations. Recognizing whether your work is soft, loose, precise, evocative, or moody is an important consideration in the choice and application of colored pencils and their related accessories.

Once you have taken stock of your needs and interests, purchase the best pencils you can afford. You know that you have acquired good pencils as soon as you apply them to paper; the color will flow smoothly and the colors will be rich. Try to stay away from colored pencils that are manufactured with school-age children in mind. These likely will produce bland colors, even when applied with pressure. Student-grade pencils often contain excessive clay grit that mars the drawing surface and impedes the application of color.

Test a few pencils before agreeing to buy a full set. You should be totally satisfied that you are acquiring pencils produced with the artist in mind. It also is wise to make sure that individual pencils of the brand you choose to purchase are readily available on an ongoing basis. Artists tend to work within a specific range of colors and don't regularly need a full set.

Choosing wisely will provide its own rewards in the future. Once the selection process is behind you, you

Colored pencil leads come in various thicknesses. Lyra of Germany produces the thickest colored pencil leads, which are wonderful for free-flow sketching as well as finished drawings. Berol's Verithin line offers a hard, thin lead that produces precise lines.

can focus on the main task at hand: the rendering of your perceptions in the rich immediacy of colored pencils.

To help get you started with the right tools and pencils, the following pages contain descriptions of the equipment basic to colored pencil drawing, as well as useful accessories.

COLORED PENCILS

What are they and how do they do what they do? The manufacture of colored pencils is similar to that of the graphite pencil. The circular "lead" consists of shaped and bonded pigment wrapped in a wooden casing. The agent used to bond the pigment is usually a cellulose gum. The bonding process also uses wax, which gives each pencil its color-spreading qualities. Pencils with more wax spread their color more smoothly, but when applied in thick layers, "wax bloom" may occur.

Wax bloom: A problem? Wax is used as a binder in the manufacture of colored pencils and helps color flow vibrantly. When colors are applied with a light to medium pressure, the wax content does not hinder or af-fect color. When heavier applications are used, wax bloom may occur.

Wax bloom, simply defined, is the result of wax rising to the surface of a drawing when color is applied heavily. It may occur a few hours after an application, or appear a day or so later. Bloom gives a drawing a dull, drab or flat gray appearance, even though the colors used may have been brilliant or intense.

Wax bloom is not so much a problem as it is a by-product of heavy pencil application which simply has to be dealt with. It may be compared to the need to add mats and glass to protect a finished drawing.

Wax bloom can be eliminated with the careful rubbing away of the waxy film, using a tissue or tortillons. (Tortillons are discussed more fully, later in this chapter.) The brilliance of the applied colors will then immediately reappear. To permanently halt the recurrence of bloom, spray the drawing with several light coats of fixative.

Transparency: Colored pencils are transparent in nature, much like watercolors. The impact of colored pen-

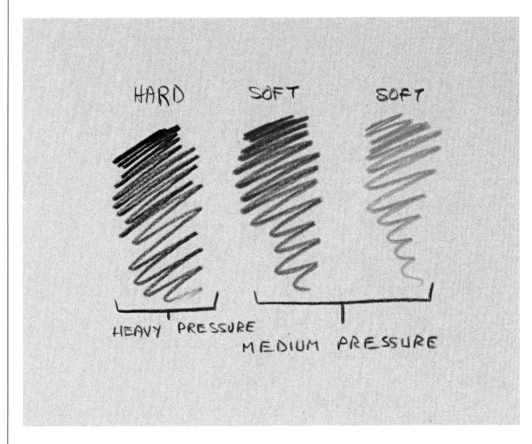

Depending on the wax content utilized in the manufacture of various colors, different pencils will have hard, medium, or soft degrees of ease in application. Only personal experimentation will determine which degree of smoothness suits your particular application needs.

cil applications is much stronger when one or more colors are overlaid to form a final new color.

Quality pencils: Quality colored pencils are produced throughout the world. The major brands available in most countries are Berol Prismacolor—United States; Lyra (made by Rembrandt-Polycolor) and Faber-Castell (Polychromos)—Germany; and Derwent (made by Rexel-Cumberland)—Great Britain. They may be distributed by the manufacturer, or through an agent, who stocks your local art supplier. There is little difference in the quality of colored pencils from one reputable company to another. Colored pencils pro-

duced for artists are usually of the highest quality.

Types of pencils: Some colored pencils, such as Berol's Verithin line, are produced for precise line rendering, though they also have good tonal layering qualities. Their leads are harder, creating little, if any, feathering and are useful in more graphic styles of color production where more precise line rendition is necessary. Don't mistake quality hard-lead colored pencils with those less-expensive pencils manufactured as student-grade. Both have hard leads. The difference is in the application of the color: quality pencils, despite the hardness of the lead, will still produce rich colors.

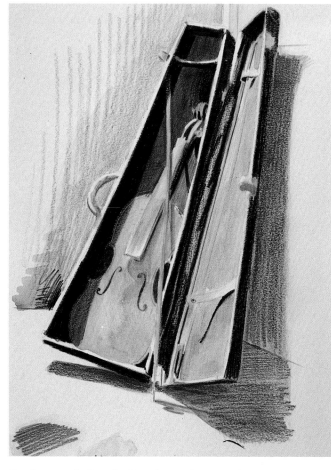

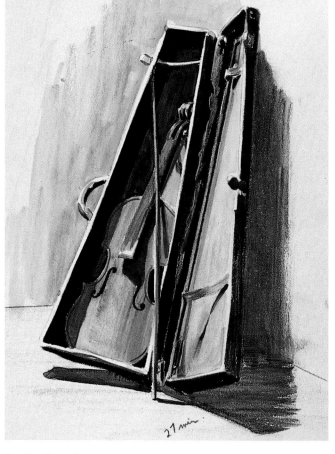

Student-grade Pencils: It took one hour for me to reach this stage in the sketch of an old violin using student-grade pencils. Though extensive hatching and tonal layers were applied, the color saturation was weak. Once water was added to the color, the results were washed out and gray. I couldn't seem to achieve any sparkle.

Quality Pencils: After only twenty-seven minutes of color application, both dry and wet, the result using quality pencils is dramatically different. Applied dry, the water-soluble pencils flowed with rich color. Even without the addition of water the sketch had life to it. The oranges were orange and the blues, blue. Though far from finished, this sketch proved beyond a doubt that buying good pencils is worth the search, experimentation, and slight difference in cost. The step-by-step demonstration (Water-Soluble Pencils) on page 8 is done with Rexel Derwent watercolor pencils.

WATER-SOLUBLE PENCILS

Few artists are familiar with water-soluble pencils. The fact that they resemble watercolors may deter those who are hesitant about that medium. In essence, they are the same, but they are also different. Despite the application of water prior to or after a color application, water-soluble pencils retain some of the linear qualities associated with pencil.

Water-soluble colored pencils are made by several reputable manufacturers, such as Rexel-Cumberland, Faber-Castell, Schwan-Stabilo, and Caran D'Ache. These colored pencils not only apply color as standard colored pencils do, but also are soluble when water is added to the sketched drawing surface. Their application combines the linear quality of the pencil stroke with the transparency of watercolor.

It is very important to try out water-soluble colored pencils before purchasing them. If the lead from one of these pencils is too hard it will not produce a rich color when water is added. The result may discourage you from the outset. Try out different brands; the pencil that gives you the smoothest flow of pigment also will give you the richest color once water is applied.

Demonstration: On the following page is a step-by-step demonstration of a drawing called *Lazy Daisy*. The flower was picked by one of the many neighborhood children who find our dog, fish-laden fountain, and large garden too good to resist. The child stuck the daisy in the eyelet of one of our lawn chairs, where I found it.

Water-Soluble Pencils: Once water is applied to dry strokes of a water-soluble pencil, the pigment spreads immediately, giving a drawing the look of a watercolor. Note that when water is applied to a drawing with linear applications rather than tonal applications, the drawing retains this linear quality.

DEMONSTRATION
WATER-SOLUBLE PENCILS

Step One: After sketching the daisy and the lawn chair in graphite, I apply a single dry tonal layer of bottle green to the grass; orange chrome, middle chrome, and indigo blue to the chair; and indigo, black, and light blue to the aluminum frame and springs. The daisy stem needed emerald green and the center of the flower, light to heavy applications of a golden brown.

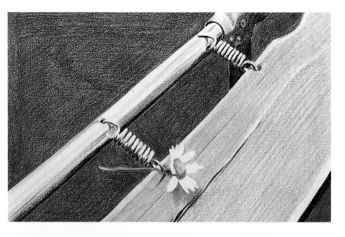

Step Two: As with watercolors, wet pigment is intense and rich. Once dry, though, it may look flat. The bottle green grass seems to have grayed, though the other colors are vibrant. You will notice that some pencil colors, like watercolors, are more transparent than others. These tend to retain the intensity of their initial application. More opaque colors, once dry, resemble a gouache rendering.

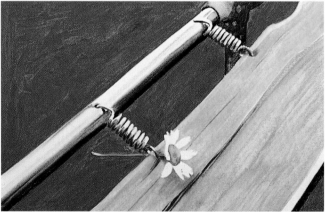

Step Three: Though I want the grass background to recede and be less busy than the main subject of the drawing, it should still retain life and movement. I accomplish this by applying bottle green, ochre, and May green in irregular, grass-like strokes. I use a blunt point and heavy pressure without defining too graphically the blades of grass themselves. Some strokes of colored pencil are applied over the wet wash, where they blend instantly into the wash. This helps to soften the impact of the new strokes and pushes them into the background. I then redefine the aluminum frame using the same pencils as before. A light wash gives it a smooth metal-like texture.

To complete the drawing, I apply more tonal layers to the webbing, using orange, ochre, and kingfisher blue. The contrasting weave pattern in the webbing seems lighter, so I use a sharp point with heavy pressure on a white Berol Verithin pencil to impress the diagonal lines.

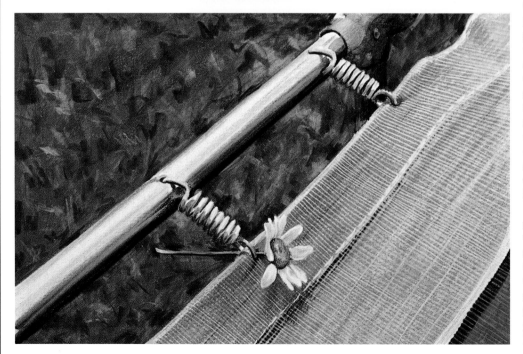

COLORED STICKS

Some pencil manufacturers, such as Berol Prismacolor and Rexel-Cumberland, produce drawing sticks that are color-keyed to their existing line of colored pencils. These sticks resemble Conté or pastel sticks in shape and length and have the approximate consistency of the colored pencil to which they are keyed. The obvious advantage is their use in a more free-flowing application of color. They can be sharpened or sanded into points of various shapes. Their ends and sides and corners offer a wide variety of subtle or intense application possibilities. Since they are not encased in a wooden sheath, they can produce a wide flow of color along their whole length (approximately three inches).

ERASERS

Different types of erasers are used in colored pencil drawing. They are not always used as removers of unwanted applications. They can tone color applications, soften harsh treatments, and highlight specific areas of a darker application. The only eraser you should avoid is the pink school eraser. Over time it hardens, and if it feels dry to the touch, it will probably stain your drawing surface with its telltale pink. You should also avoid any erasers with trendy colors imbedded in the manufacturing process.

Varied papers or other drawing surfaces react differently when different erasers are applied. To discover their potential, scribble a series of crosshatched strokes on different papers and test each eraser's properties. Try to keep your erasers as clean as possible by rubbing away residue on a scrap piece of paper. (Erasers sometimes will retain color picked up from previous uses.)

Types of erasers: Erasers are categorized by general usage: ink eraser, pencil eraser, typist's eraser. Today, there also are plastic erasers of various shapes and sizes. These are user-friendly because they can be accurate in areas where fine definition is necessary, and can also soften tonal values without harming the drawing surface. Some erasers have their own pencil-like holders.

Erasers: Erasers are useful for blending or eliminating color. When erasing it is important to consider the fragile nature of drawing papers. Patience is needed when trying to remove a color passage. Speeding up the process will only worsen the situation. A combination of utility blade and eraser may be needed to eliminate unwanted color completely. This is a time-consuming process. Be patient and careful; the drawing surface must not be damaged.

Colored Sticks: Colored sticks are a useful addition to your regular colored pencils. They cover large areas of a drawing surface where the usual procedure of tonal layering using a regular pencil would be extremely time-consuming. They are also fun to use in their own right, providing you with a less-constrictive tool for drawing.

Gum erasers are soft and useful in blending and erasing, but their propensity for crumbling easily and for losing their characteristic cube or rectangular shape makes them less desirable.

Kneaded erasers are completely flexible and can be molded to suit the artist's purpose. They can be shaped into a point or given a wide, flat, or round configuration. These erasers seem to "eat" residue and come out clean when kneaded.

Cut and shaped to suit individual needs, erasers are an important part of the drawing process.

SHARPENERS

For those who rely on the qualities of a hand-hewn pencil point, blades are still the best sharpening tools. For those who enjoy the rapidity and exactness resulting from hand or mechanical sharpeners, a variety are available. In the studio, the old-fashioned hand-crank sharpener is still a favorite. Due to its simple and rugged design, it is easy to maintain and its grinders are not easily clogged. Created for office and school use, these sharpeners can take a lot of abuse, and still retain their

usefulness. Another advantage of the hand-crank sharpeners is their template, which can hold varying thicknesses of pencils. They come in portable models that have a strong suction cup as well as those that mount on a wall or tabletop.

Miniature hand sharpeners are inexpensive yet precise. The most resilient are made of metal. Some come with two sharpening slots: one for wider pencils and one for thin-body pencils.

Electric pencil sharpeners also are available, but I use mine for graphite pencils only, because the wax in colored pencils tends, with constant use, to clog the mechanism.

Sandpaper blocks: These are used to give a pencil point a custom shape. Many artists create their own strokes in pencil drawing and use sandpaper to get the precise pencil point. Sandpaper blocks are available in various shapes and sizes and often come in thin pads. When a fresh block is needed, simply peel back the used one. A more economical substitute is the regular sandpaper fingernail file. It also has another advantage: a rough and a smooth side.

Blades: Knives and blades are useful tools in the colored pencil drawing process. They are used to scratch and/or scrape color from the drawing surface, as well as to shape pencil points. Sharp knife blades are good substitutes when more refined blades are not available.

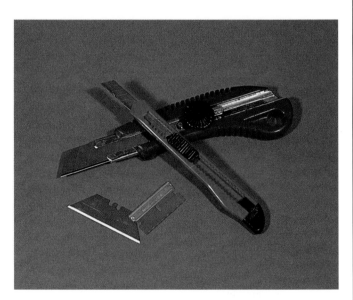

TORTILLONS

Tortillons (pronounced tor-tee-yons) are tightly rolled paper stumps used to soften or blend colors. They come in various sizes and thicknesses. One or both ends are sharpened to a point. Once used, they retain particles of pigment, which can be removed by sanding with the sandpaper block. This cleaning process also will help maintain the tortillon's point.

SPRAY FIXATIVES

Various manufacturers, such as Grumbacher and Talens, produce spray fixatives that are used to protect finished drawings. Spraying is useful in removing wax buildup or freshening up work put aside for a few days. Use only professional fixatives that guarantee no yellowing. Fixatives come in matte and gloss finishes. Follow the application directions carefully to avoid irregular blotching of the drawing surface. Heavier applications of color may need more layers of spray. Be advised that protective sprays often intensify color applications. In general, this does not harm or hinder the impact of the drawing. I tend to spray lightly several times, even those areas with no color applications. In this way, the whole surface is uniformly covered and protected. These sprays always should be used in a well-ventilated area or, better yet, outdoors.

PENCIL EXTENDERS

Various types of pencil extenders are traditionally used with charcoal sticks, pastels, Conté crayons, and graphite pencils. They are just as useful with colored pencils. Since the sharpening of pencil points is often repeated in the drawing process, pencils tend to get short rapidly. Extenders allow you to get the most out of even the shortest pencil stub.

Sharpeners: Personal choices or preferences dictate which sharpener will suit individual artists. There is no "one" way to sharpen your tools; use whatever way is most practical for you.

Tortillons: Tortillons are most useful when you wish to blend one or several colors into a smooth layer, especially on rough paper. Some subjects may demand softening, despite the texture of the chosen drawing surface. Varying sizes of tortillons can serve an artist well when a too-rough surface detracts from the desired texture.

PENCIL HOLDERS OR BOXES

Pencil sets come in boxes of twelve, twenty-four, thirty-six, sixty, or seventy-two. These boxes often are not compatible with an artist's working style. Packaged in slide-out containers created to facilitate usage, the pencils often prove troublesome. They are difficult to remove from the designer boxes and thus are distracting; the selection, pulling out, and putting away demand too much of your attention. You may want to organize the various pencils in holders more suitable to your own personal needs.

Artists often invent tools to meet their specific requirements. Many years ago I made a wonderful pencil holder by sawing a discarded two-by-four to a twenty-four-inch length. I then drilled three rows of twenty-three holes each, approximately three-quarters of an inch apart. Each hole was five-sixteenths of an inch in diameter.

This pencil holder holds a complete box of sixty assorted colors, plus tortillons and extenders. The holes are numbered according to the number-rating of each colored pencil. This tool has served me well for more than fifteen years. Storing the pencils simply means picking up the loaded holder and slipping it into the cupboard. An added advantage of this type of holder is that you can always tell by each pencil length which ones need replacing.

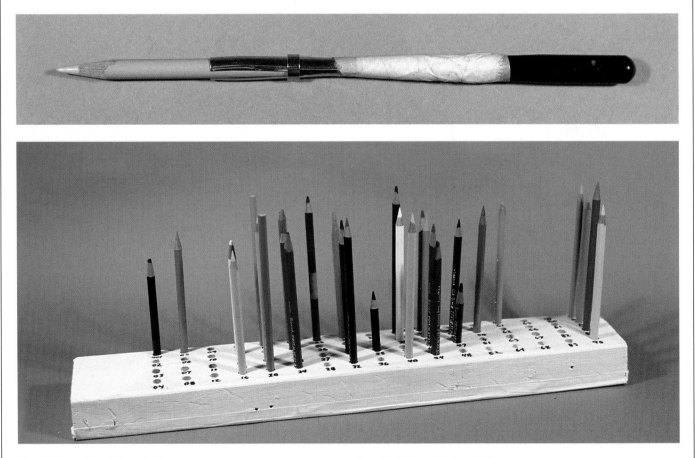

Pencil Extender: (Above.) My pencil extender has seen better days, but it is one of the most useful tools in my studio. Though simple in design and inexpensive as art tools go, an extender can save you a lot of money by extending the life of a too-small colored pencil stub.

Pencil Holder: (Below.) The simplest pencil holder, and one of the most useful and economical, is still a leftover length of two-by-four in which holes have been drilled. Glue a bit of felt to the base, and the completed holder will sit well on a drawing table, even a slanted one, and store easily.

TERMINOLOGY

How much do you know about that pencil in your hand? Here is a short explanation of what goes into a pencil, plus definitions of a few other terms you may have heard and used but never entirely understood.

Crosshatching. The use of crisscrossing sets of hatched lines for shading or modeling. (See Hatching, below.)

Directional lines. Parallel lines laid in a specific direction to create a desired effect; for example, a series of lines used to tone a drawing by following the shape of an object.

Gradated. Shaded imperceptibly from one color or tone to another. A tonal layer is gradated when it is applied with varying pressure, creating varying—usually either increasing or decreasing—intensity of tone.

Grisaille. A foundation for an artwork done in shades of gray.

Hatching. The use of clusters of parallel lines for shading or modeling.

Layering. Applying one color over another to achieve various color effects.

Lead. The core of any pencil. The graphite in black writing pencils has been called "lead" for many centuries, and we use the term even with colored pencils. A colored pencil lead is pure color pigment mixed with a wax binder.

Modeling. Emphasizing three-dimensional shape using wire-like lines bent to the varying shapes of an object.

Nondirectional or multidirectional lines. A series of lines, often in parallel bunches, that are stroked in various directions to imply texture rather than shape.

Sheaf. The wood envelope that surrounds the colored lead in a pencil.

Stippling. Hitting the paper with a sharp, blunt, or chisel-edged pencil. Repeated over and over, this creates an impressionistic effect. When stippling with two or more colors the final color achieved is the result of the combination of the colors utilized. Studying the paintings of the French Impressionist Georges Seurat will help you understand the power of the stippling method.

Tone. The result of applying lines of color so closely together on a sheet of paper that they seem to form one even layer of color, sometimes called a tonal layer.

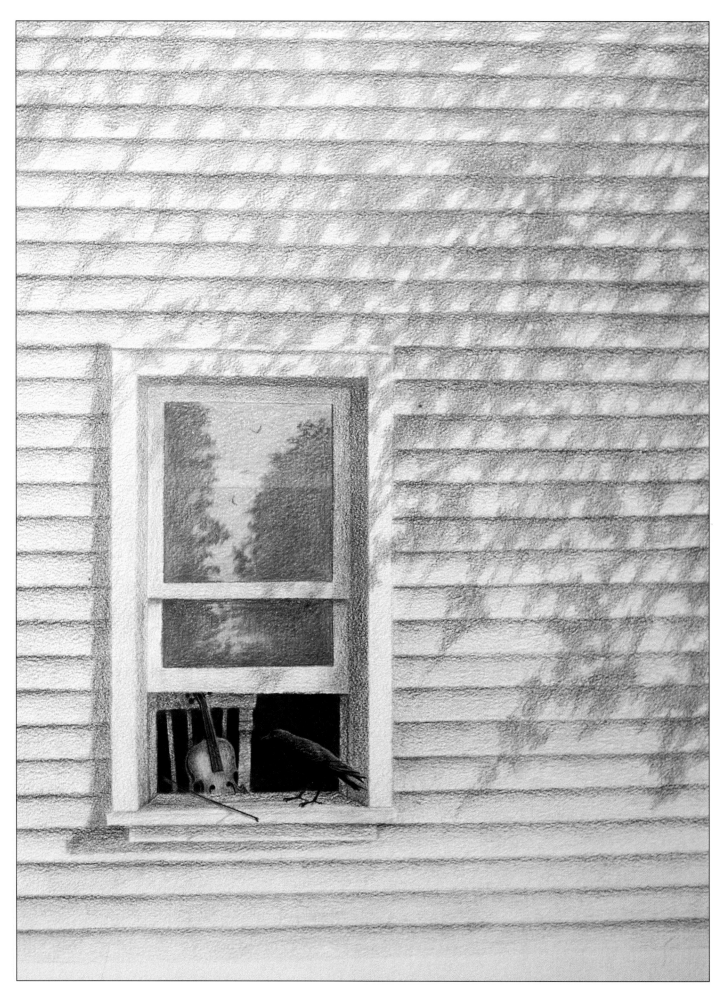

STUDIO SPACE

TAKE FIVE
Allan Servoss

A studio can be anywhere, any size. It can be in your attic, the basement, or behind the garage. When I was a college student many years ago, I was destitute (as many students thought they were). The college was hundreds of miles from my family home, so I rented an eight-by-ten-foot room in a boarding house. This small space was my bedroom, living room, study *and* studio. I vividly remember this room where my early sketching and anatomical studies were done. At home I shared a bedroom with no less than three of my brothers. This tiny, private studio space was heaven to me.

After fifteen successful years in the fields of teaching and therapy and thirteen full-time years as a profes-sional portrait artist, I finally have a fairly large studio — and I still need more space! Everything is relative.

Colored pencil drawing takes up very little room. If all you can spare is a cupboard, don't despair. Storing tools in a small, easily accessible area is more important than having a large, permanent studio. Let's begin at the very beginning: Let's take a look at various types of spaces that can serve well as a studio.

CLOSET STUDIO

Since colored pencil drawing demands few tools or ac-cessories, a drawer in a bureau will do well as a starter. From there you can grow into larger quarters, such as a

Closet Studio: A closet studio needs few accessories and can be outfitted in one afternoon. A shelving unit screwed into the back wall holds your reference material: books and colored pen-cil equipment. Below, a ¾″ × 36″ × 30″ plywood sheet can be hinged to the back wall with inexpensive piano hinges, available in your local hardware store. To support this table at the desired angle, a 1″ × 2″ length of wood can be used. When not in use, the table folds down neatly against the wall. To your left or right, a small rack or shelving unit can hold your drawing papers and boards. To complete the studio, add a com-fortable stool and an overhead light, and voilà!

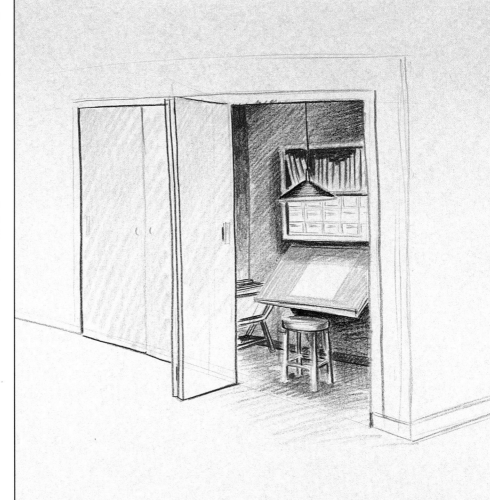

closet. Closets—not necessarily the walk-in kind—make great studio spaces. They are unobtrusive, space-saving, and private as well. If you live in an apartment, outfitting such a space is fairly simple. (See the illustration on the facing page.)

MOBILE STUDIO

Another alternative studio is an all-in-one, indoor mobile station. It wheels away whenever you are through with drawing and fits easily in a family room, den, or downstairs recreation room. This all-inclusive piece of furniture holds everything you need: books, drawing papers, clamped lamp, adjustable drawing table, pencils,

accessories, and chair. When you are not creating artwork, it can double as a regular table by simply covering it with a tablecloth. This mobile unit is definitely a do-it-yourself project for those of you who like to build or know someone who does. (See the diagram and instructions on the following pages for details.)

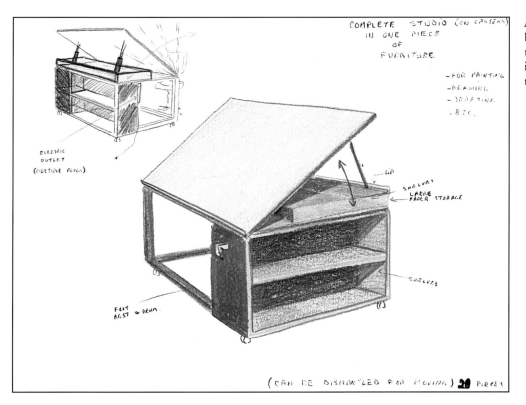

Mobile Studio: Here is the mobile studio. It is not too difficult to build yourself. On the following pages are detailed instructions.

BUILD YOUR OWN MOBILE STUDIO

This unit comprises twenty pieces. It can be taken apart and put back together again if you have to move.

Materials you will need:
- Two 4' 2×4s (front and back braces)
- Two 3' 2×4s (side braces)
- One 28½" 2×4 (single leg; height should be measured to suit)
- Two 12"-deep×28½"-high shelving units, each 3' long
- Two ¾"-thick finished plywood sheets, each having a 3'×4' dimension (unifying shelf and drawing table-top)
- Two ½"-thick finished plywood sheets, each having a 3'×2' dimension (paper storage unit)
- Two 2' 1×2 lengths of wood (sides of paper storage)
- One 34" 1×2 length of wood (end of paper storage)
- Two 4' lengths of edging (pencil holder along front of drawing table and back wall to hold adjustable legs)
- Two strong door hinges (to support drawing table at various angles)
- Two adjustable legs (to support heights of drawing table)
- Four casters
- One multiple-outlet extension cord (provides outlets for lamp, pencil sharpener, etc.)
- Twelve 3" wood screws
- Twelve 2" wood screws

Instructions: Join 2×4s to form a 3'×4' frame. Screw together with the 4" side facing up. Placing the shelving units upside down, form a 90° angle with them. Position the constructed 2×4 rectangle over the shelving unit bottoms. Screw the frame into the shelving units, using the 28½" length of 2×4 to support the fourth corner. Once the units are secure, screw the 28½" leg to the frame at the fourth corner.

With someone to help, turn the unit right side up. The shelving units should now be sitting astride the 2×4 frame. Fit one of the two 3'×4' plywood sheets atop the unit. Screw it securely to the shelving units and the support leg. Install the hinges to the secured plywood sheet. Position the tabletop to the hinges and secure it from the bottom side. Fold the table down atop the unifying plywood sheet. Install the two edgers, one along the bottom of the drawing table and one along the back edge of the unifying sheet. Turn the whole unit on its side. Install the four casters. Attach the multiple-outlet extension cord to the underside of the unifying sheet of plywood.

Build a paper storage box with the remainder of the wood. This box sits underneath the drawing table when it is angled for drawing.

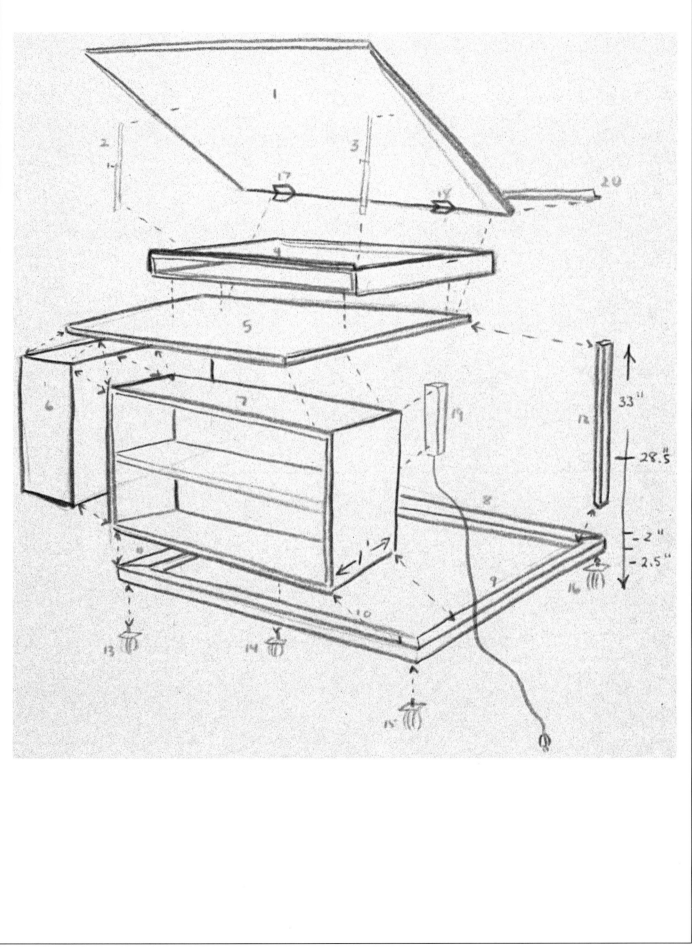

OUTDOOR STUDIO

Working outdoors is always a thrill. It also is good training. Concentrating while others hover over your shoulder, offering unsolicited comments and suggestions, is something we all have to learn. Someday, those same people will haggle over who will be the lucky person to pay top dollar for your yet-unfinished masterpieces. (Don't laugh, it happens!)

Setting up easily and quickly is essential. Therefore, your studio must be portable. Racing the clock to capture a scene in changing light is more important than having elaborate paraphernalia. Fancy equipment may look professional, but it takes too much precious time to organize and set up.

Simplicity is the key to a well-organized outdoor studio. Begin with a stable easel. Winds can ruin a whole day's efforts if your easel wobbles or topples over. Many easels are available for outdoor use. One I enjoy using is the wooden, collapsible studio easel called the Chameleon. It's available from your art supply dealer. Its flexibility is outstanding. It adapts easily to any terrain, adjusting to your working height and style with a simple twist of three knobs. Portable and lightweight, it holds the smallest drawing surface as well as full-size sheets.

A collapsible canvas and aluminum bench will add to your setup and is a better alternative to squatting or sitting in moist grass.

All other tools can be carried in coat pockets, a sketch box, or a fishing tackle box. I prefer a photographer's vest. (See the illustration on the facing page.)

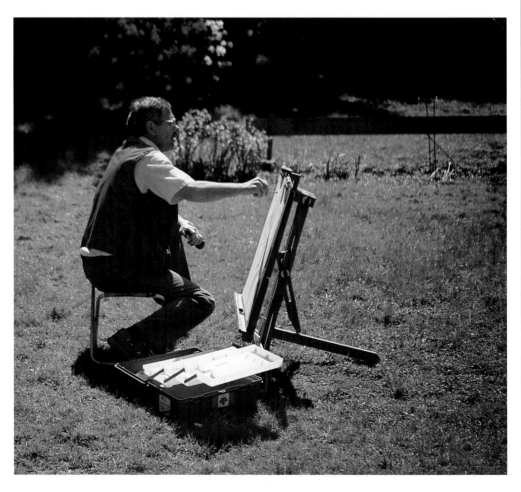

Outdoor Studio: The Chameleon will fold down for those who prefer sitting, and extend to a full six-foot height for those who wish to stand. The extra height handles large canvases or drawing boards easily. The easel's flexible three feet will sit solidly on slanted terrain.

MY PERMANENT STUDIO

Having a bona fide studio is definitely the ultimate heaven on earth. If you are patient (or when the kids grow up and leave home), the time will come when space is available with an honest-to-goodness real door that opens and closes when you want it to!

As shown on the following pages, my studio is L-shaped and spacious: the larger section measures twenty-seven feet by twelve feet and the smaller, nineteen feet by twelve feet. Each section is divided into work areas. Most of the accessories and equipment were designed to meet my personal requirements. What I could not find in the marketplace or considered too expensive, I designed and had made by friends and acquaintances with the needed expertise. When prices for certain pieces of furniture seemed exorbitant, I purchased similar items in department stores and adapted them; e.g., two cabinets on casters, one for carrying my drawing tools and one for my painting equipment, are simply altered microwave cabinets. (Bought in local department stores, they were much cheaper than comparable items in art supply stores.)

Wall-to-wall industrial carpeting covers the studio floor. Cushioned floor coverings are a godsend to artists who use pencils extensively. Pencils have a tendency to "jump" off your drawing table, causing themselves invisible, yet irreparable damage. Leads break inside the wood casings on impact with the floor. This shortens the pencil's lifespan and causes severe artistic irritability.

As you can see, I am fairly spoiled. Can you imagine, it's only taken me twenty-five years to get this great studio!

SUMMARY

Setting up a working studio requires considerable planning and organization. Each area should be designated carefully, so that you don't keep running around from one end to the other, wasting precious drawing time.

Good luck on the organization of your own space. Remember, what counts is that you can find a way to work happily in the space you have! Truly, the rest doesn't count. Being an artist means being creative despite obstacles and opposition. Now, let's get on with colored pencil drawing. We've looked at equipment and work areas. Let's now take a look at drawing surfaces.

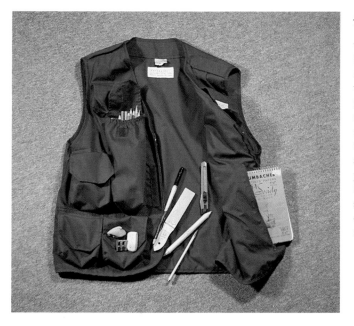

Fisherman's or Photographer's Vest: These vests are lightweight, permitting you to carry in total comfort all the tools you need. Mine is similar to those worn by fishermen and has a zippered front and more Velcro and zippered pockets than I'll ever need. Inside front panels have flat zippered pockets that hold seven-by-nine-inch sketching pads. I wouldn't be out sketching without one. My hands are always free for the easel and my drawing board, and the equipment is always at hand.

Note: The various areas of the studio are numbered in a logical progression, rather than following a clockwise order.

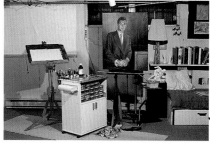

Area #6: Next to the lounge is the painting area. All of my watercolors and oils are produced here. Two large studio easels and a cabinet on casters are the only equipment present, because I like to have enough room to view large paintings from different angles and at a distance.

Area #7: At the end of this same section is a framing area, canvas storage bin, and a handmade paper storage. Everything I need to frame and package finished work is organized here.

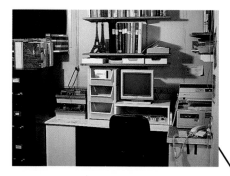

Area #2: To the right I organized a communication and filing area. Here, I have the telephone and computer.

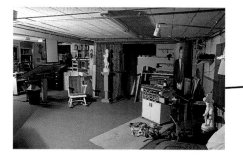

Area #1: In the smaller section of the studio, my drawing table dominates. All reference material and tools related to drawing are easily accessible, including a built-in bookcase. Next to the books is a custom-made light table, where I view slides and transfer drawings. On the opposite side of the bookcase there is a rollaway cabinet (microwave stand), holding all of my accessories and pencils, sketch pads, and reference material. Along the length of this section, I have a wall-to-wall bookcase and deep shelves that hold paper, photography equipment, and stored artwork.

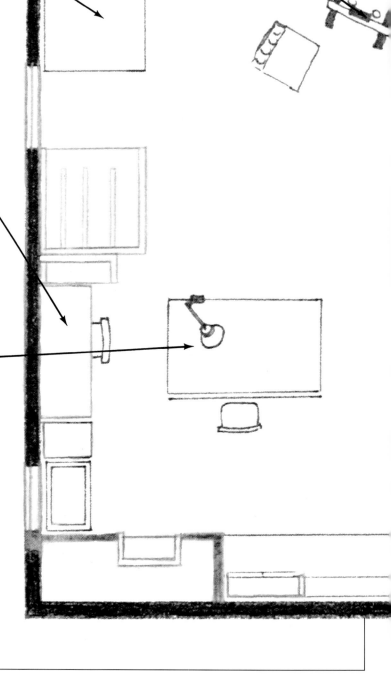

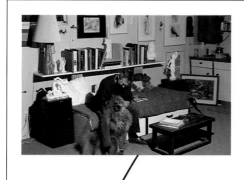

Area #5: In front of the cleanup area is the lounge. A sofa doubles as a comfort zone for clients and visitors and a posing area for models and portrait sitters.

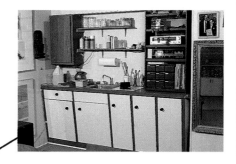

Area #4: Within the larger area and to the right of the entrance is a sink and storage area. Here, I wash all of my brushes and soak watercolor paper. This area is also where I keep my stereo equipment and tapes.

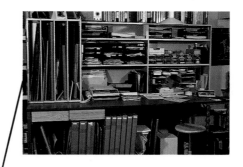

Area #3: Opposite the area with my drawing table and reference material (Area 1) is the office area. Deep, vertical storage shelves beneath the custom-made desk hold drawings and paintings.

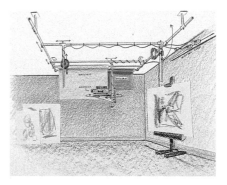

L-shaped Studio: Here is a floor plan of my permanent studio. I have come a long way since my first small live-in studio. You certainly don't need all this to be a successful colored pencil artist, but it does provide comfort and convenience.

Lighting: In the larger portion of the studio where portrait sittings are staged, I have designed and installed track lighting. It's simply a series of interlocking and adjustable pipes that, when fixed to the ceiling, provides me with accessible and versatile lighting capabilities and backdrop supports. Off-the-floor wiring eliminates potential accidents, such as clients tripping over wires.

PAPERS AND OTHER SURFACES

UNTITLED
Bill Nelson

Colored pencil drawings can be accomplished on an endless variety of surfaces. The choices you make depend not only on the techniques used, but also on whether you wish to create artwork simply for the moment, or whether it is to withstand the test of time.

The most frequently used drawing surface traditionally has been paper. This surface comes in a variety of textures and permanency ratings. Plastics, such as neutral pH Chronaflex, gessoed boards, coated polyester, wood, and many other surfaces also take colored pencil applications well. Each surface has its own characteristics that add a particular dimension to your colored pencil work. Based on the makeup of these surfaces, the end product will be permanent or fugitive; smooth, rough textured, or painterly. Serious consideration of a personal work surface should take place before you begin drawing.

Experimentation and the use of protective measures, such as sprays, varnishes, glass, and ultraviolet-resistant framing techniques will help extend the life of artwork produced on questionable as well as archival surfaces.

Though experimenting is part and parcel of being creative, most artists desire to produce finished art with a long and healthy lifespan. To this end they must rely on papers and boards manufactured to meet strict and consistent archival and/or museum-quality standards. This means that the drawing surfaces chosen should have a 100 percent "rag" content and/or be pH balanced.

Rag is the term used when papers are produced from a pulp of cotton, jute, or other natural fibers other than wood. Having a neutral pH balance means that the paper is neither too *acidic* nor too *alkaline*. These terms refer to the ability of papers to retain color, shape, and density despite the natural or man-made light sources that may illuminate them for an extended period of time. These drawing surfaces have been created to serve the special needs of artists and archivists. No chemical whitening agents have been used that could weaken the fibers or fade the natural color of the paper.

For this reason, it's important to find a local source of quality, acid-free drawing surfaces. Once a drawing is completed, it's too late to worry about the quality of the rendering's support panel.

Manufacturers respect artists' demand for the best possible papers and boards. A knowledgeable distributor can acquaint you with updated information concerning the ingredients used in paper-making processes as well

as the manufacturer's guarantee. If your art supply dealer cannot provide you with the correct information or the paper you wish, switch suppliers or order from a dealer in a larger city. Your local library has telephone books from every city in the land. From these you may choose the nearest dealer in your area.

Just as a house cannot stand for very long without a solid foundation, neither will drawings endure on a doubtful surface. With a little time and effort, you easily will become proficient in the reading of good drawing papers or boards. You may even fall in love with specialty papers and discover (like I did) that papers are addicting and in themselves, fascinating. Visiting your local art supply store for a paper "fix" could become part of your regular routine.

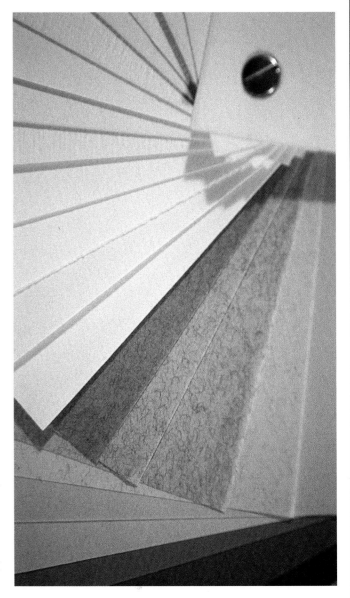

TYPES OF PAPER

Having come this far, it's time to look at the different types and finishes of available paper. There are two basic types: machine-made and hand- or mold-made. Relying on tried-and-true brand names is the best way to start your love affair with papers.

A paper's finish: A paper's finish refers to its tooth, grain, or texture. This characteristic permits the applied color from the pencil to cling to the drawing surface.

All papers used for drawing need some degree of "toothiness." This does not mean that a paper must be rough in order to be a good drawing surface. Some papers can be fairly smooth yet still have good tooth. For instance, Arches' satine or Lanaquarelle's satiné watercolor papers are probably the smoothest you would want to use to complete a finished piece of art. A smooth-surfaced paper is sometimes referred to as having a fine

grain or as being hot-pressed. Medium-grain papers are those with a slightly rougher texture, and thus more tooth. These papers most often are chosen by colored pencil artists.

Completely smooth papers—those with a polished or coated finish—and those with a very rough texture are not generally recommended for pencil drawing. However, with a specific technique or idea in mind, they too can be acceptable drawing supports.

Smooth or hot-pressed papers give good results when pencils with harder leads are used. Rough surfaces accept more readily the colored stick's wider and bolder applications.

Can you rely on those brand name papers available in local art supply shops? The answer is yes. Some manufacturers, such as Fabriano, have been producing quality art paper since the thirteenth century. Other brands

Smooth Surface: Fine-grain or smooth paper produces results that are soft and tonal rather than linear in appearance. The tooth of the paper allows for more color saturation. This paper finish lends itself readily to finely detailed work and more precise line renderings.

Machine-made papers. (Left.)

Medium Surface: It is obvious that a medium-grain surface has more hills and valleys than smooth paper. This surface is highly regarded by colored pencil artists, since it holds color well and allows more of the paper's own color (white, in this case) to shine through. If papers have a mood, this one is more vibrant than the smooth surface. Some artists may find the linear pattern annoying to the eye, however.

such as Ingres, Arches, Canson, and Schoellershammer are as legendary as the Masters who have used them throughout the ages.

Since you most certainly will be purchasing the best pencils for your needs, let's take a closer look at the types of surfaces upon which you can safely hatch and apply tonal layers.

The art and science of making good-quality paper, be it hand- or machine-made, is an exacting one; however, let me try in a few short paragraphs to explain how it is done.

MACHINE-MADE PAPERS

Machine-made papers offer few, if any, surprises. Their consistent nature and surface are appreciated by artists who depend on these inherent properties to achieve the predictable results they want.

High-grade, machine-made papers created specifi-

cally for artists are acid-free and/or pH balanced. They will resist yellowing and other deterioration common to paper. As well, quality papers will more readily withstand the rigors of the drawing process.

Different companies use various screens and felts that, together with the lay of the fibers, give specific papers their telltale qualities and textures. I recommend extensive experimentation on those surfaces with which you are already familiar. Once you know exactly how a paper will react under the pressures of your particular application techniques, treat yourself to a new paper every second month or so. In this way you will create a precise record of which soft, medium, and rough textures meet your requirements.

Don't shy away from testing papers not specifically created for the drawing process. Their individual properties will expand your reference file.

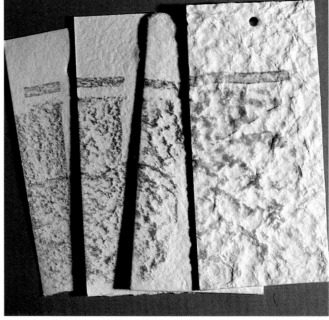

Rough Surface: Having more tooth than the two previous samples, rough-textured paper strives to be aggressive and expressive. Pencil strokes on this paper appear more active, their lines less fluid and more scattered. Colored sticks lend themselves well to surfaces such as this. The paper's valleys shine through, giving integrity to the finished work.

Roughest Papers: These are samples of paper that have been produced with watercolorists in mind. It is intriguing to see the results obtained through the combination of colored pencils and the vast irregular valleys and hills. Art sticks or the Lyra Color-Giant pencils are good choices for experimenting on such rough surfaces.

HANDMADE PAPERS

The characteristics that make machine-made papers valuable do not apply to mold- or handmade papers. Though machinery has been part of the process for many years, the creation of handmade paper is still very much a "hands-on" exercise. Unlike machine-made papers, each handmade sheet is unique.

In handmade paper, the fibers—which do not fall in any particular direction or specific pattern—give each sheet a distinct and unique surface.

The best of handmade papers are created with old cotton, jute, or linen fibers. That is the implication behind the often-used term *rag paper*.

The production of handmade papers is arduous and exacting. While machine-made papers have a constant surface texture, handmade production is rarely consistent. This is part of its appeal. Using it is always a new experience. The only constants are the quality of the production techniques and the fact that mold-made papers also come in smooth, medium, and rough textures and weights.

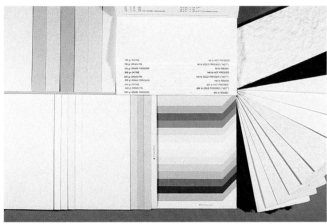

Here are some examples of machine-made papers, (immediately above). To the right (top and bottom) are examples of handmade papers.

COLORED PAPERS

The choice of colored papers in art supply stores is endless. Many of these papers are better suited for craftwork than for drawing, as most are not colorfast or acid-free. (Buyer beware!) As with white drawing surfaces, I cannot repeat often enough how important it is that you purchase acid-free, rag paper. Some name brands assure you of top-quality colorfastness. You can test this promise of quality by setting squares of various colored papers in the sun for a few hours or days. Overlap each square to the center, exposing only half of the square to the sun. Though this may be an extreme method of proving a paper's colorfastness, it will give you a better idea of which papers' claims are valid.

No matter how careful you are in keeping framed drawings from direct sunlight, over time there will be some color loss. The degree to which the paper color fades depends on the intensity and duration of direct light striking it, whether it be natural or manmade. Generally, slight fading from reasonable exposure will not unduly affect the quality or impact of your artwork.

Canson Mi-teintes papers from France seem to be the most readily available colored drawing papers. They have a medium-grade texture on one side and a smoother surface on the other. Both surfaces are pleasing to work on. Canson also offers a wide variety of colors, from the deepest black to the softest pastel shades. Their only drawback is that they are fairly thin.

Once framed, thin sheets of paper may buckle when hung in areas of the country where humidity is high or varies constantly. To solve this problem, the paper can be dry-mounted with acid-free dry-mounting tissue onto acid-free board prior to drawing.

An alternative is to use four- to eight-ply archival or acid-free matting boards. These have either a smooth surface or a regular pattern of machine-made texture that artists find pleasing. These textured surfaces may resemble a weave or a pebbled pattern. I prefer smooth-surfaced boards, though their lack of tooth allows for fewer overlapping color applications.

HER FAVORITE OUTFIT
Bernard Aime Poulin

For this portrait I chose a rather bright yellow paper to enhance the warm thoughtfulness of my subject.

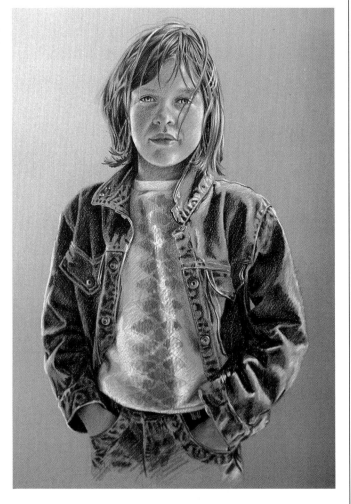

OTHER SURFACES

Despite the emphasis on the use of rag or acid-free papers for drawing, other surfaces lend themselves to colored pencil work that is not necessarily being created for permanency. This is not to say that work on these surfaces will not last. I am simply saying that there is no guarantee because of the acid or chemical content of their makeup. On this page I show some examples of other surfaces. On the following pages there are four master drawings, each done on a different surface.

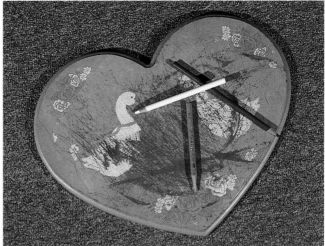

Wood: I chose colored pencils rather than paint to repair the paring knife-damaged image on the surface of this old cutting board. The gouges and cuts add character to the board and I didn't want to hide them with paint. After re-creating the damaged areas (see parts of the duck on the left), I varnished the board and hung it on the wall. The results are quite pleasant.

Coated Mylar: Strokes and tonal layers on coated Mylar seem to negate the surface and appear suspended. The surface, though very smooth, holds colors well. Its slightly translucent quality blends the various color applications completely, while retaining the individual characteristics of each hue. Applications may be done on one side or both sides of the sheet.

Coated Vinyl: This surface is similar to coated acetate except for the toothier surface. Like acetate, color can be applied to both sides of the sheet, allowing more color saturation.

DAYDREAM
Bernard Aime Poulin

Used Watercolor Paper: I never throw away watercolor paper on which I have applied a lackluster color wash. Whenever an experimental mood strikes me, I use these sheets for sketching. This drawing of a daydreaming model is quite successful. The feathered lines sitting high on the hills of this heavy watercolor paper seem to be standing still, but only for a short time. A less-rugged paper would have been too soft to achieve this feeling.

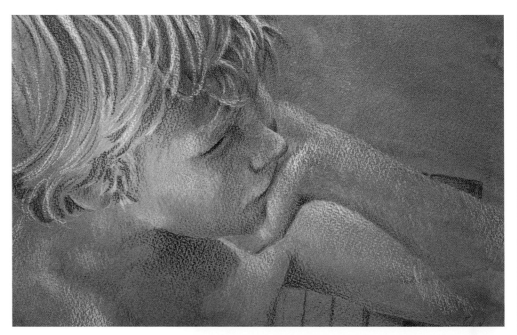

BUTTERFLY
Bernard Aime Poulin

Standard Paper: Despite the fact that what we see may be in focus, the mind's eye may perceive a blur of movement. The standard or medium-toothed papers can help create the illusion of movement by feathering strokes and lines applied to it. The strokes of a soft colored or graphite pencil when applied to a toothed paper will be feathered, and therefore less graphic or precise. Using a too-soft paper would have made the child's upward reach too static.

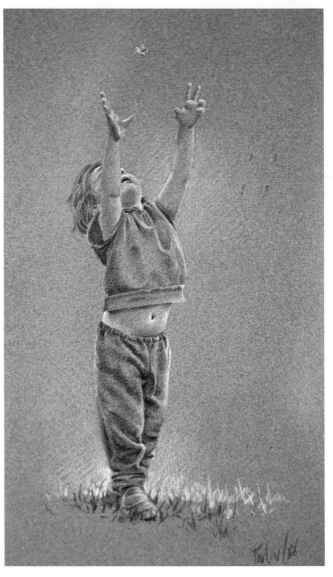

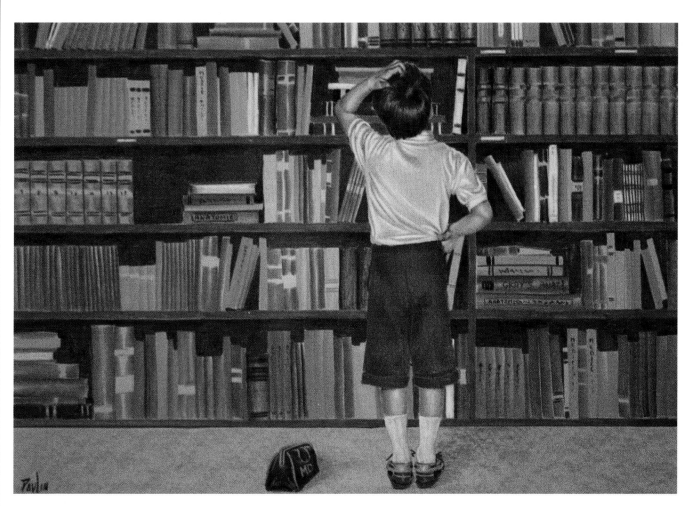

WHAT'S ANATOMY?
Bernard Aime Poulin

Smooth Paper: Even the use of a standard-texture drawing surface would have been overkill in a drawing such as this. The loaded bookcase already acts as a textured foil for the small, soft figure in the foreground. The repeated rectangular shapes and varied colors of the book covers create enough of a texture, so a smooth paper was the best choice for this rendering. Selecting just the right drawing surface can mean the difference between a so-so exercise or a successful drawing.

VENICE HOUSE
Robert Guthrie

Mylar: Applying light to medium tonal applications to the Mylar surface, Robert has achieved a highly successful interpretation of this interesting facade. Note that he retains the reflected light from the brightly sunlit areas in his shadow areas. Mylar, acetate, and vinyl surfaces hold color well, even when thin lines are applied. There is no feathering, giving each stroke a crisp personality.

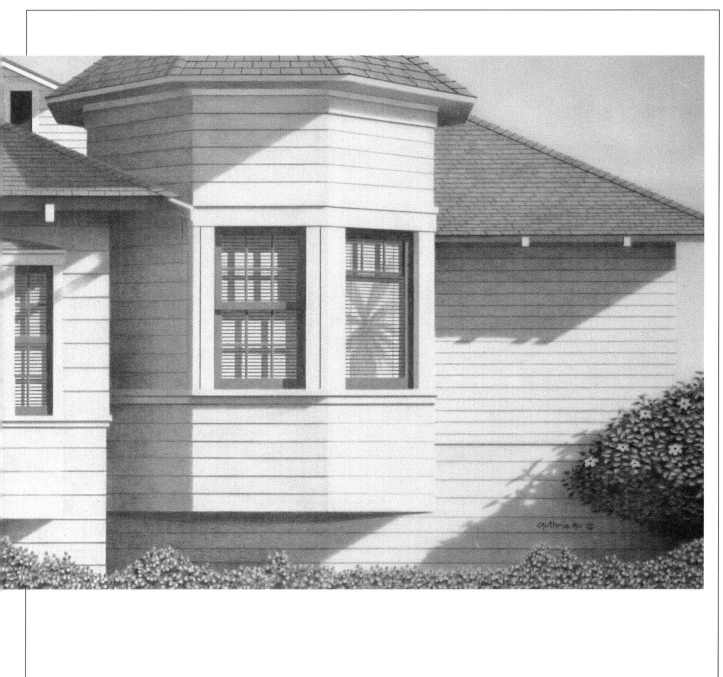

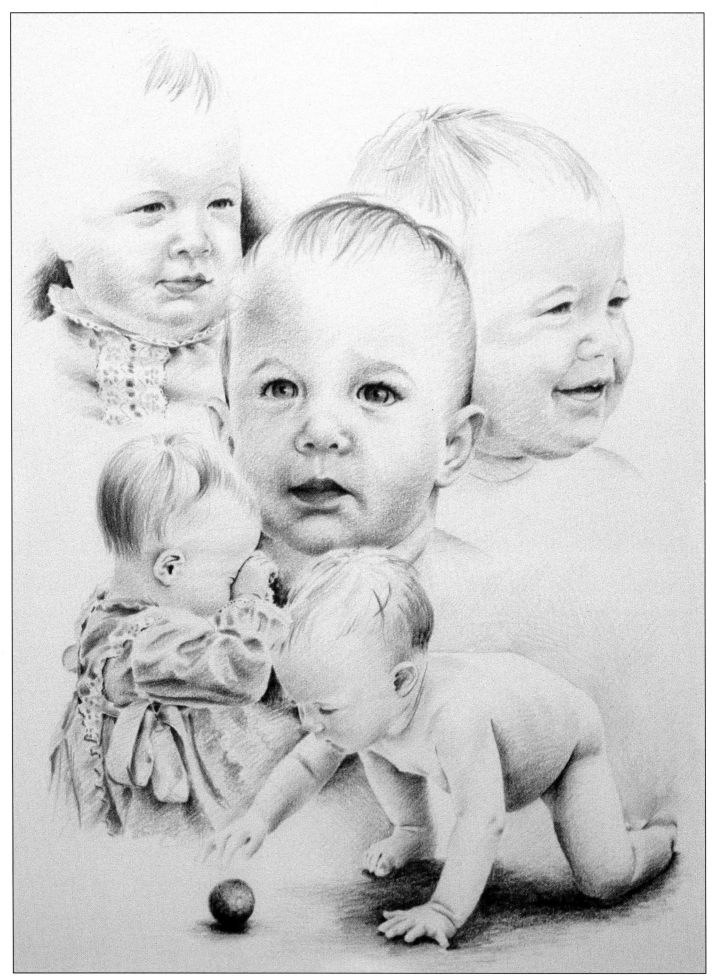

THE PRELIMINARY SKETCH

CHILD STUDY
Bernard Aime Poulin

Sketching, beyond the usual preliminary drawings, can be an end in itself. With only a few colored pencils and a pad of drawing paper, the mall, the beach, or even your local fruit and vegetable market can offer myriad fascinating opportunities for sketching. Apart from being a good habit, sketching for pleasure will help you improve the spontaneity of your finished work. Getting the hand to respond quickly and assuredly to what your eye sees is valuable training.

Colored pencils can play a major role in the improvement of your observation skills. Sketching with a graphite pencil is simpler, because everything you record is done with the same pencil. On the other hand, when using colored pencils the advantage is that you must learn to quickly reach for the next color while continuing to observe and record the subject before you. This matter becomes even more complicated when your subject is moving. Your patience and ability to relax, absorb, and capture the passing scene will most assuredly be tested like it never has been before.

Nonetheless, sketching as an exercise before creating a finished piece is still the best way to discover which details are important and which are subordinate.

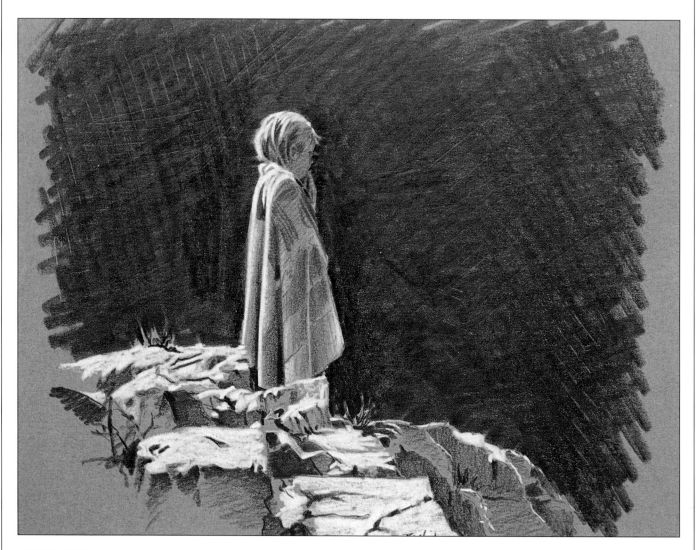

AT THE EDGE
Bernard Aime Poulin

This is a high contrast drawing
with a lot of drama.

PRELIMINARY SKETCHING

How you decide to go about beginning a drawing in colored pencils should be based on how quickly you want to enter the color phase of your drawing as well as how quickly your eye captures the established values through a series of preliminary sketches. These preliminary sketches wil raise the following questions:

- How dark or light are the values in the subject I have been sketching?
- Did I render them accurately?
- Is the mood the observed subject evokes present in my sketch?
- Can I improve on my sketch?
- Is the drawing worth pursuing, or should I find something else to draw?
- Should I begin again?

Once you are satisfied that your sketches have provided you with the information you are seeking, you can either continue refining them until they become finished drawings or use them as references for more refined drawings later.

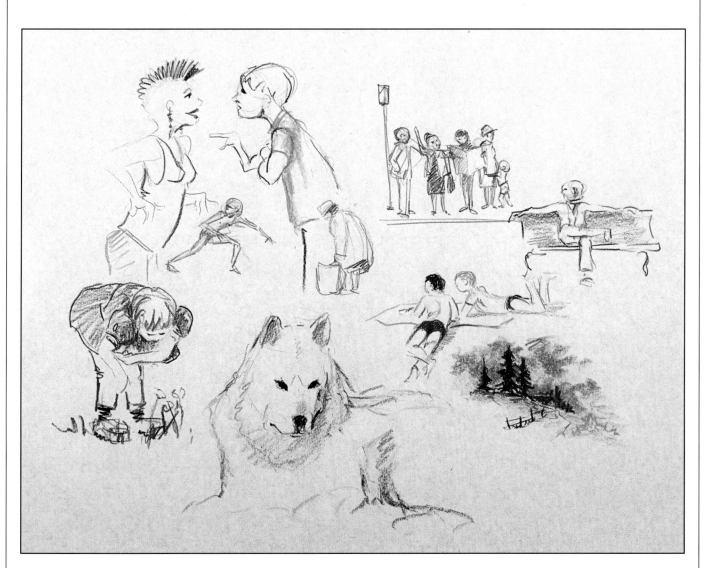

This page out of my sketchbook shows the range of material I consider sketching prey. No matter how long you've been at it, you need to keep your hand and eye keen by doing lots of drawing.

REFINING A SKETCH

As an artist I like to mix the best of old-fashioned techniques and the best of modern materials and methods. I am always on the lookout for equipment and techniques that allow me the freedom to accomplish my work with greater quality and efficiency. Yet, creating a finished drawing is always difficult, despite twentieth-century gadgets. A drawing is rarely successful and usually more difficult to complete if the "bugs" aren't worked out before color is applied.

The following illustrations and captions describe the procedures I follow in refining a preliminary sketch.

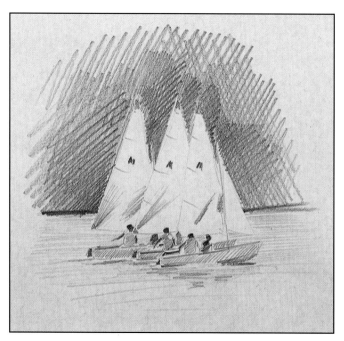

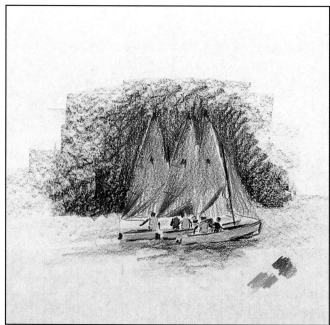

Using Graphite Pencils: I sometimes like to use an HB or B graphite pencil as a sketching tool. In this way I can concentrate completely on the values to be rendered and not worry about the effect colors might have on my observations.

In this sketch, I wanted to capture the translucent red sails of three racing boats passing before the dark background of a forest. The sun was behind the forest and the boats, bathing the sails in a luscious translucent glow. A black-and-white sketch helped me measure how the lightest lights and darkest darks would play against each other.

Using Colored Pencils: Resketching the same scene in colored pencils, I tested various color choices to establish which I would be using and how intensely I would have to apply and blend them in order to achieve the desired results.

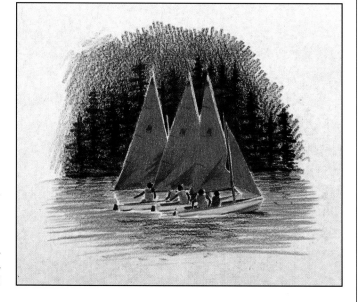

A More Refined Sketch: It's obvious that both previous exercises proved to be valuable. It has been nine years since these sketches were done, and I am still thinking about using the information to do a finished drawing—if only I can find the time!

SKETCH TO FINISH

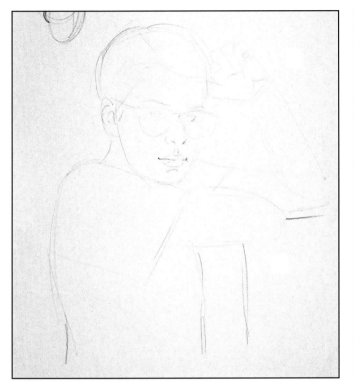

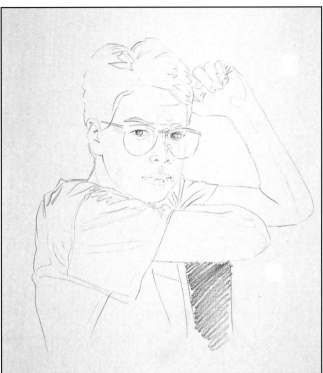

Step One, Preliminary Sketch: After several trials and errors, I arrived at this particular pose, which has been freely rendered in graphite. I am anxious to establish proportions and exact shaping of the forms I see before me.

Step Two, Refining Shapes; Delineating Value Areas: I begin to refine the lines, becoming more and more aware of the subtle nuances in line direction and intensity. After a while the drawing surface is overloaded with corrections and extra lines.

Step Three, Transferring the Drawing: Using a light table, I transfer only those lines to be retained onto a new sheet of paper. This process is repeated several times. Once I discover a hint of the mood I am looking for, I begin to delineate light and shadow areas.

41

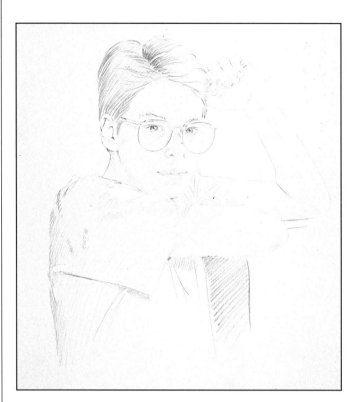

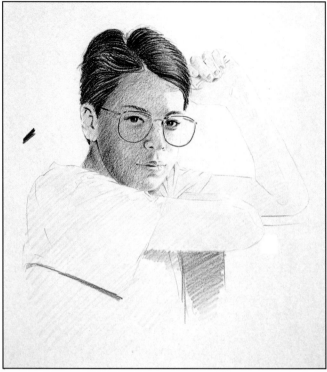

Step Four, Establishing Values: If I'm not sure of the value areas, I hold back on transferring the sketch to good paper. Instead, I retrace the sketch via the light table and begin establishing tonal values in earnest. This allows me to see more clearly whether I am on the right track or not.

Step Five, Establishing Values With Color: Another way of establishing values before beginning the finished drawing is to do a value study in color. This method also allows you to discover the most effective and accurate color combinations.

Step Six, Transferring the Finished Sketch: Once I'm sure I have all the information needed to proceed with the finished drawing, I coat the back of my refined sketch with graphite powder or a soft graphite stick and place the sketch over a sheet of quality drawing paper or board. Tracing carefully is the last step in the refinement stage. It's now time to complete the finished drawing.

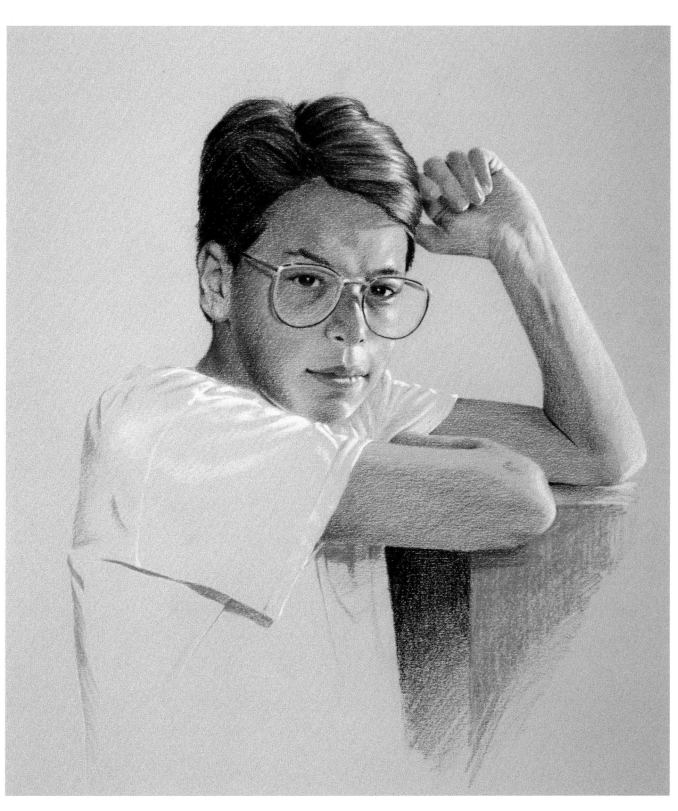

MARCO
Bernard Aime Poulin

Despite the last value study on Marco, I couldn't maintain the harshness of the shadows and retain some of the gentleness of my subject. Yes, Marco is a bright adolescent, a self-assured young man whose determination is strong. Yet, I wanted to hold on to the gentler, warmer side of his boyhood. This I could not do without softening the intensity of the shadows. Deep and dark, they rendered Marco's determination aggressive. By warming up the shadows and diminishing the value contrasts, I was able to ease up on the tension and focus on the boy's honest and direct look.

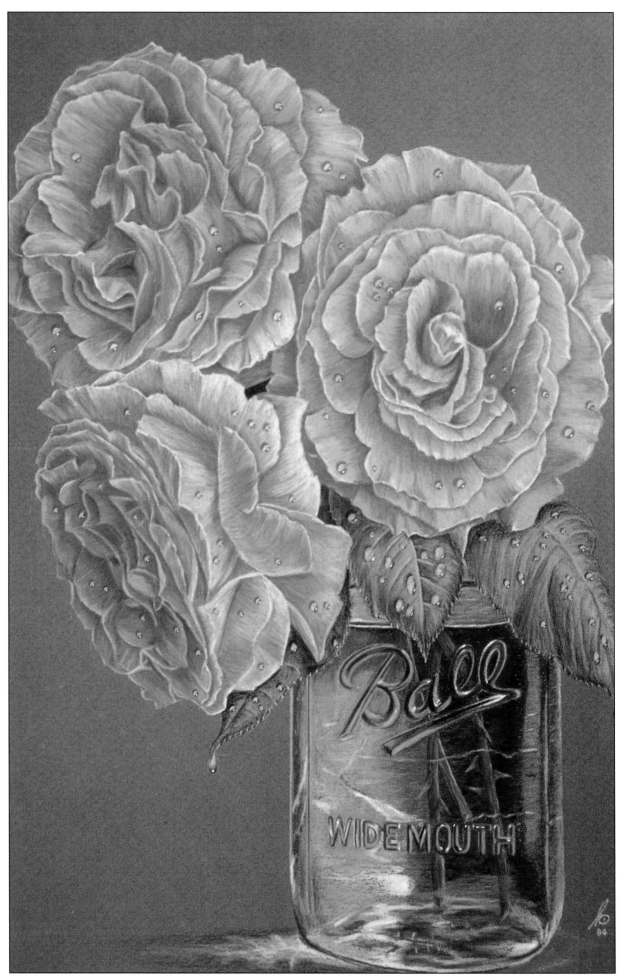

THE IMPACT OF COLOR

THREE ROSES AND A BALL
Gary Greene

As the words imply, *color* and *pencil drawing* are what colored pencils are about. The vibrant and sensual qualities of drawing can be enhanced with color which, when applied judiciously, adds to the visual and emotional impact.

Color has enormous influence on our lives. Automobiles, furniture, clothes all are attractive to us, in part because their colors make us feel good, bad, aggressive or calm. We have similar reactions to the visual power of a work of art. The impact depends on specific dimensions all colors have. For our purposes, the most evident are hue, value, intensity, and temperature.

HUE AND VALUE

The name we give a color is its hue: blue, red, orange, purple, etc. Since the hue of a color changes when it is mixed with another color, its name also will change; red mixed with yellow will produce a new color: orange. The value of a color refers to its lightness or darkness as measured against a graduated value scale or "gray scale," which has black at its darkest end and white at its lightest end. The grays in between graduate from the darkest (next to black) to the lightest (nearest to white).

By sliding a gray scale up and down alongside a specific hue it's possible to determine the value of that color. The process is simple: close one eye and squint with the other. Compare the hue with the value differences on the gray scale. Eventually you will hit the correct value of the particular color. Colors nearer the white end of the scale are called "tints." Those nearer in value to black are called "shades."

The value of a specific color can be altered to meet your requirements. Black is the simplest way of immediately darkening or shading a color. Judge very carefully whether the black is warranted as a shader. Used heavily, it tends to dominate and deaden the intensity and vibrant impact of the altered color. When white overlays a color it will lighten that color's value as well as dull its intensity.

BLACK, GRAYS, AND WHITE

Black, grays, and white fit into a category all their own. They are called achromatic colors, or neutrals. Black,

Intensity: A color's intensity increases with the amount of pressure applied. Once an intense color such as green bice is overlaid with lavender, it not only loses its intensity, it also changes color.

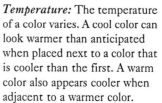

Temperature: The temperature of a color varies. A cool color can look warmer than anticipated when placed next to a color that is cooler than the first. A warm color also appears cooler when adjacent to a warmer color.

grays, and white have one thing in common: when mixed with a color they alter the intensity of that color.

INTENSITY

A color's intensity is its degree of brightness or "chroma." Pure, unmixed colors are usually the most intense. At times, the brilliance of a specific hue must be altered. To dull a too-brilliant color, overlay it with another hue. This will decrease the brightness of both the first and second colors.

TEMPERATURE

Each color has a temperature. Colors nearer to the reds and yellows are said to be warm. Those nearer to the blues are known as cool. A warm color will become cooler as more and more of a cool hue is added to its basic warm temperature. The opposite also holds true: a cool color to which an increasing amount of warm color is added naturally becomes warmer.

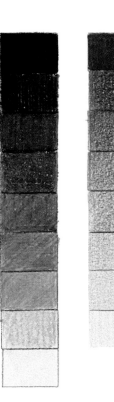

Gray Scale: The Modular Color Value Finder, from Permanent Pigments of Cincinnati, Ohio, has been a faithful value chart in my studio for quite a few years. It helps the artist accurately ascertain the value of a specific color.

FASCINATION
Bernard Aime Poulin

BOY CLOWN
Bernard Aime Poulin

Color on a White Surface: The immense power of color is felt as soon as it is applied to a white drawing surface. Color, as we subjectively expect it to do, spreads out before us in all its brilliant glory. Due to the transparency of colored pencil applications, the white surface melds with the applications and adds brilliance to the final result. Each color is viewed and perceived to be the one the artist has chosen and applied.

COLOR ON TINTED DRAWING SURFACES

Most of what you have read so far relates to colors applied to white paper or a white drawing surface. Our perception of a color is altered dramatically when confronted with hues that are applied to a surface which is also tinted. The temperature, the intensity, and the value of the drawing surface all play their part in how each applied layer of color is perceived. Further into the book, additional displays of drawings will help to illustrate this phenomenon.

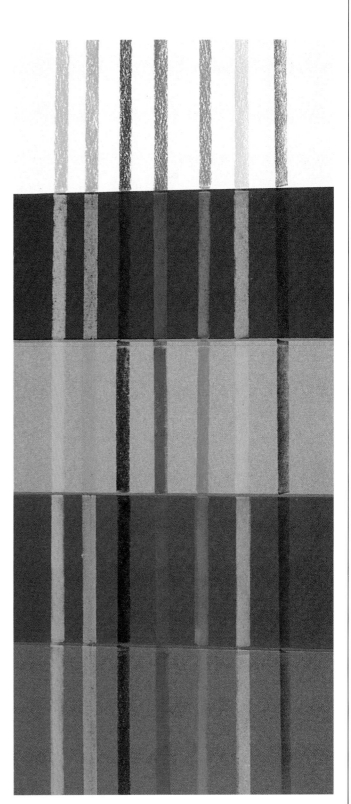

Color on a Colored Surface: When you compare colored pencil applications made on tinted drawing surfaces to those on white paper, several observations can be made: (1) The value contrasts between surface and applied color has been altered. (2) Most colors are more luminous on a tinted surface. (3) The hue is different; for example, yellow over indigo equals greenish-yellow. (4) The intensity of the colors is altered. (5) The temperature of each color also has been changed.

It is therefore important to choose colors well before applying them to a tinted surface. What you see may not be what you'll get!

LOCAL, AMBIENT, AND REFLECTED COLOR

The color by which an object is recognized is called local color; for example, a red apple, a translucent orange tomato, green foliage. Unless the subject of your drawing is a complete vignette with no surrounding space except the emptiness of the drawing surface, local color is always affected by the space, or ambience, in which it sits. A tomato's color struck by a bright sun and the blue of a cloudless sky will react to this ambience, which has its own color. The mingling of local and ambient color will cause a reflected color, especially on shiny surfaces.

The shelf on which the tomato sits has its own local color. When light strikes the tomato, reflected light and color from the tomato will affect the local color of the shelf. Nothing can visually exist in a color vacuum unless it is suspended in space and without light. And if that happens, it won't be visible!

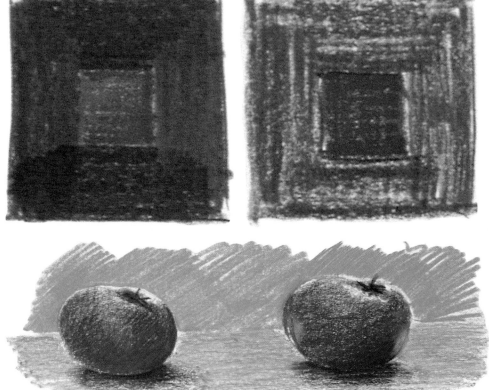

Juxtaposed Color: Applying a color next to another will alter the impact of each. Surrounding red with a layer of purple will alter both the inner and outer hues (mostly the inner, since the outer color is also affected by the tint or whiteness surrounding it).

The same red when surrounded by green is perceived to be different. Juxtaposition therefore plays an important role in the application of color. Placement of hues affects the overall impact of a rendering.

Local Color: The tomato has been sketched with only its own local color being present. A drawing such as this may be accurately rendered, but it seems to lack "presence." It's basically flat, despite its rounded form.

Ambient Color: When I add a bit of ambience to the space around the tomato, it becomes more tangible. Our mind's eye perceives it as existing in a definable space having its own color. From a window, a blue light bathes the tomato and the shelf. The color of the shelf also is altered by the ambient color of both the incoming light and the tomato.

Reflected Color: The blue-green light bathing the shelf is reflected back onto the tomato's surface, adding to the forms dimensionality.

LIMITED PALETTE

Colored pencils come in a variety of dazzling colors. The bright hues can be intoxicating. It is therefore necessary to discipline the natural urge to splash on a full array of colors in order to achieve the results we are looking for. Color should never be used unless it serves the purpose for which it is being applied. Less is better in almost all cases. Planning and choosing wisely prior to the start of a drawing will almost always ensure success. Take a look at the following limited palette drawings. I hope they convey that judicious use of color will enhance your attempts at visual communication.

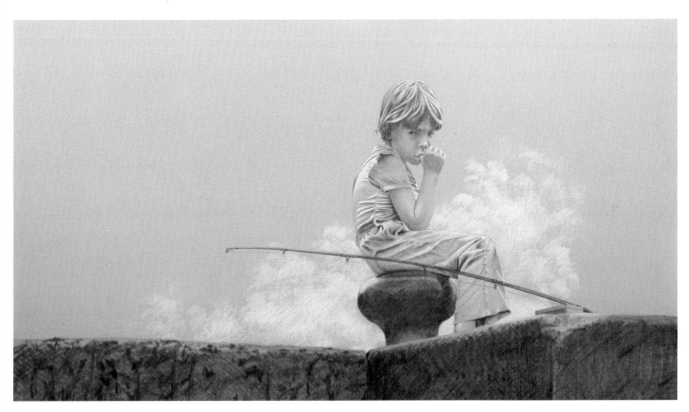

PATIENCE
Bernard Aime Poulin

Limited Palette—Graphite Plus White: I didn't want anything, not even color, to detract from the impact of this boy's expression as he waited for the fish to bite. By using a middle gray matboard surface, I was able to limit my palette to graphite and white colored pencil. The eye is also immediately attracted to the subject through the use of a limited background. The flat, horizontal composition adds to the drawn out wait and the laziness of the day.

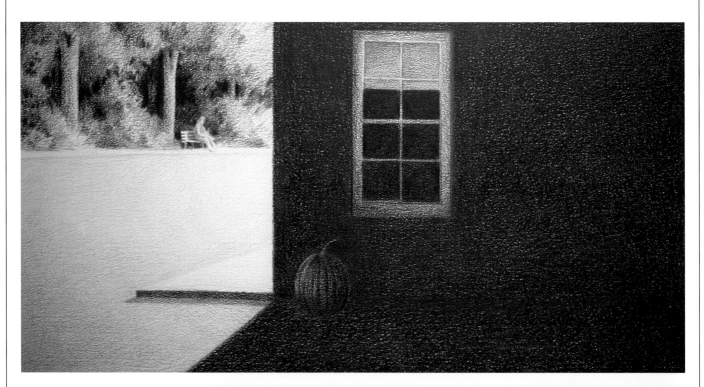

BUS STOP
Allan Servoss

Limited Palette: The subtle, yet moody themes of Allan Servoss speak well of his limited palette of colored pencils. Despite the few colors, Allan intrigues with his massive shapes and highly contrasted values. Even his shadows are alive with a sparkle that gives the dark spaces depth and impact. Knowing how much pressure is needed to achieve just the right shading is important. Allan allowed the valleys of the white drawing surface to peek evenly through the darkness, giving the impression of more color than was actually used—no flatness here!

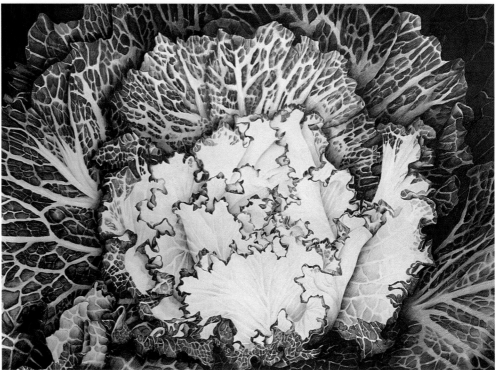

DECORATIVE KALE
Christine Fusco

Limited Palette: Christine's technical ability is so honed that she takes a limited-palette approach to the heights of fascination, both for herself and the viewer. The subtle pencil strokes and gradated tonal layers compensate our eyes' need for technicolor mastery. Christine's disciplined approach and Spartan, yet precise, choice of colors make her almost monochromatic drawings come alive.

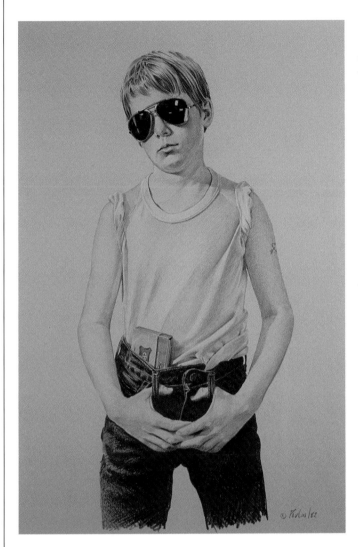

TOUGH
Bernard Aime Poulin

Limited Palette—Graphite Plus Colored Pencil: Jean-Marc wasn't really a tough guy, but his dark sunglasses gave me an idea for a drawing that might bring a smile to all of us who at one time or another thought it was so important to be "tough." The sculpting of the shapes was achieved through the use of a warm gray surface and only graphite and white. The sunglasses, as the focal point, were the result of burnishing an odd combination: bottle green over a medium application of black. White was used for the reflections.

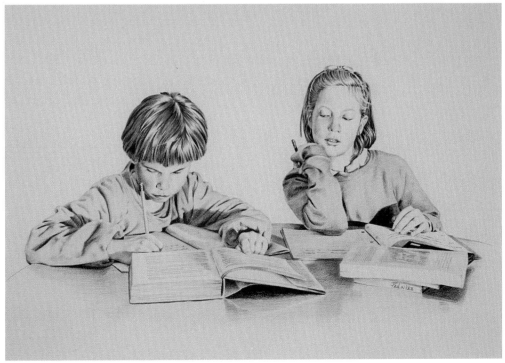

HOMEWORK
Bernard Aime Poulin

Limited Palette—Colored Pencil: Monochrome: Children are fascinating. Their lives are vibrant and full of little intrigues. The idea of "cheating . . . but not really" motivated this drawing. We all cheated as children, or tried, or at least thought about it. My daughter and a friend posed for this drawing, rendered in burnt umber. This lone color evokes nostalgia and a timeless quality appropriate to the theme. I wanted viewers to smile and remember. Adding more color would have been distracting.

CREATING DARK VALUES

The creation of dark values is more a construction than an application of a single color. Colors must be built up gradually rather than heavily layered if richness and depth are to be achieved. Ambient color, the mood of a drawing, or the intent of the artist are all bases for the choice of dark value applications. A warm or cool dark will intensify the surrounding lighter colors and add spark to even the simplest of colored pencil drawings.

Creating a dark value is not done simply to "darken" an area. The effect of the dark value also will be felt in the brighter areas surrounding or nearby.

Be wary of black as a darkener of a color. In the hands of an untrained artist, black has a tendency to drain a color of its richness while dominating the dark area with its flatness. If black is used as a darkener, I recommend using colors over the black rather than the other way around. By doing this, the subsequent applications will be emphasized rather than the black.

Even when the mind's eye reads a surface as black, this may not be so. With keen observation, the "black" you see will be revealed as a dark value that must be interpreted as a cool dark or a warm dark.

Effects of a Dark Value: In this series of steps to gradually darken an area, I first cross-hatched dark green and then overlaid this with a crosshatched tuscan red. These steps were re-peated, eliminating more and more of the white surface and deepening the tone of the area. When greens are used to build up dark values, complementary reds add rich depth to the final darkened value.

Yellow bice was applied below each step to compare the effects of each step on this color. In a brightly lit landscape, where strong contrasts would be evi-dent, these colors might be used. Note that the yellow bice appears more intense when jux-taposed to the darkest value.

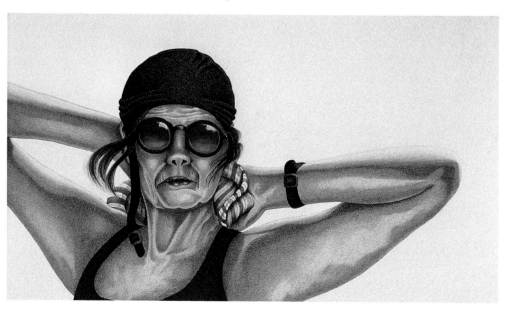

LOOKING FOR A CABANA BOY
Vera Curnow

The two main dark areas of Cur-now's drawing are very warm and rich with color. This was accom-plished by the use of layers of several colors.

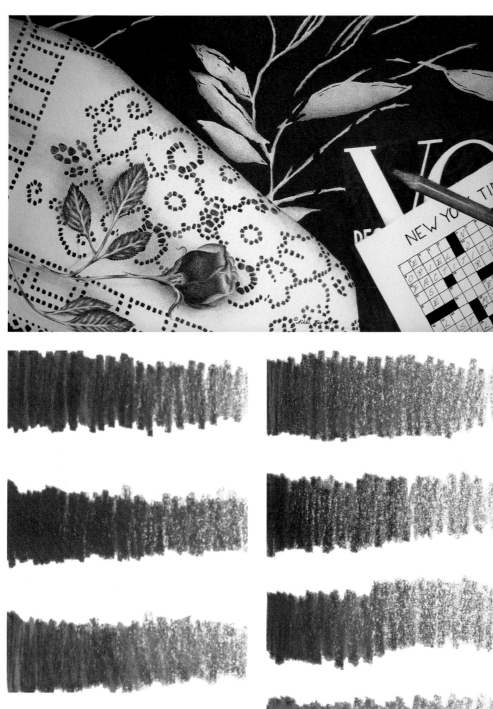

ALL THAT WE CAN BE
Nikki Fay

Large areas of flat darks are important to Nikki Fay's crisp sense of design. Here, the largest dark area (the cool blue tone) is juxtaposed to the smaller, warmer reddish tones of the magazine.

Creating Dark Values Without Black: Dark values appear warm or cool depending on the color that overlays the primary application of color; here, indigo. In the first sample, dark green is used to blend with the indigo. The green hue is cooled by the blue, yet it's warmer than the second sample, which is a combination of indigo and tuscan red. Though the red is evident, its warm hue is added to the indigo's cool tone and the result is a cool tonal application. The third sample is created by overlaying indigo with vermillion. The result of this combination is rather grayed, as the two are almost complementary. This combination is decidedly warmer than the previous sample. The last sample is a cool overlay of true blue over indigo. The results are strikingly different, as true blue is a much lighter hue than the other samples and very much lighter than indigo.

It's easier to construct rich dark values with two or more dark colors.

Overlaying Black With Another Color: Over several gradated black applications, I applied first tuscan red, then indigo blue, and finally, dark green. Though each of the dark values is deep and rich, they differ in temperature.

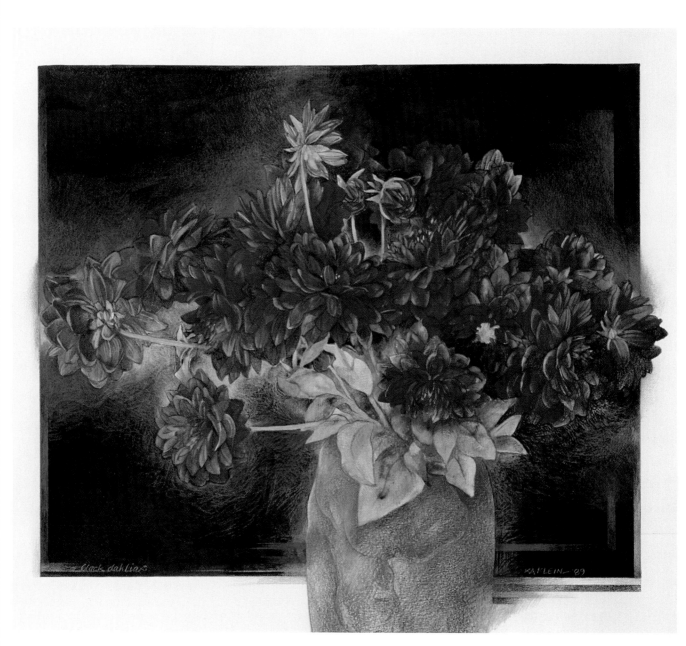

BLACK DAHLIAS
Karen Anne Klein

This drawing by Karen Anne Klein is interesting in that it is made up of almost all darks with just a bit of midtone. There are many elements that make this challenging picture work, including the one yellow bud and the midtone vase breaking the picture plane at the bottom.

CREATING BRIGHT COLORS

The most effective way to give brightness to colors is to juxtapose them with their contrasting or complementary hues. This is especially true in the case of completely saturated colors. Brightness also depends on making use of a white drawing surface's tooth. When more of the valleys appear through layers of color, more brightness shines through, giving colors a glow. This also is evident, though less so, when a neutral or high-key tinted surface is used. The brightness of a color also can be heightened by surrounding the color with another deep, dark color that completely saturates the drawing surface. A fine example is Gary Greene's *Salpiglossis*, below. In *Salpiglossis*, the translucent pinks, whites, and yellows fairly glow, due to his expert han-

dling of the colored pencil and to the powerful black areas that offer a rich counterpoint to the damp petals. Another technique is to use a dark color sparingly within a high-key drawing. Once again, Gary Greene is a master at this approach.

Other ways of brightening colors can be seen in the examples on the following pages.

For further exploration into the realm of color, I highly recommend the following two books. There are many others available, but these two are beautifully presented and offer an amazing amount of practical information, even though their main focus is not the use of colored pencils.
- *Exploring Color*, by Nita Leland (North Light Books)
- *Mixing Color*, by Jeremy Galton (North Light Books)

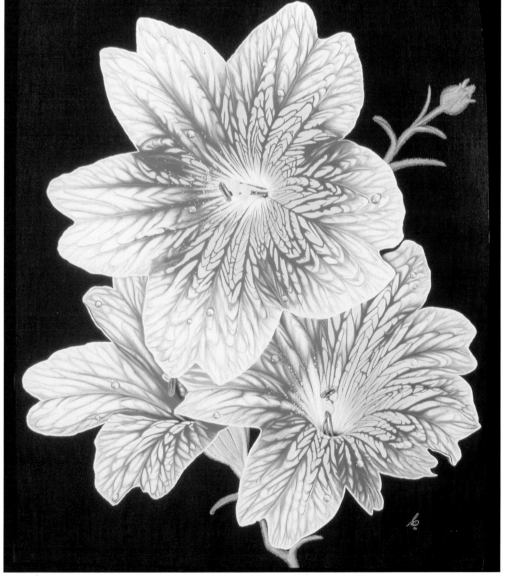

SALPIGLOSSIS
Gary Greene

This drawing shows beautifully how the use of strong darks can heighten the brightness of the other colors in a drawing.

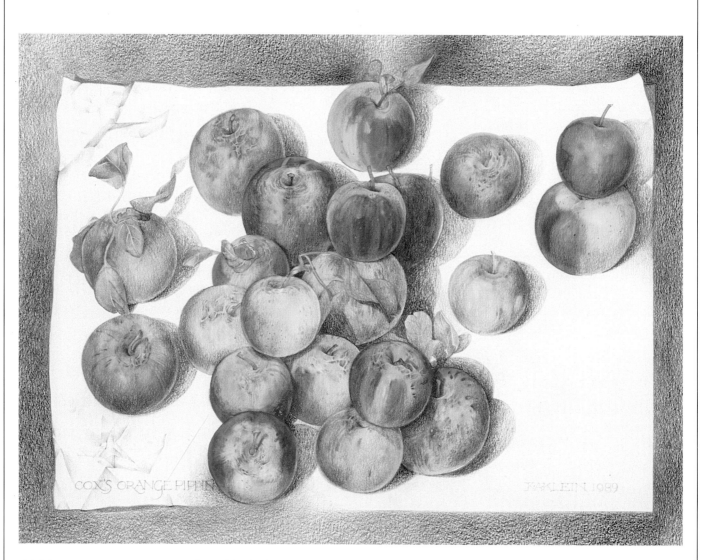

COX'S ORANGE PIPPINS
Karen Anne Klein

Karen Anne successfully heightened the brightness of her drawing of luscious apples by weighing a few essentials: First, she used a white drawing surface. Second, she used purple shadows to intensify the yellows in the apples. The greens in the trim and in the few leaves have the same effect with the reds. Third, her dark green background contrasts sharply with the white of the paper surface under the apples. And finally, her hard edges increase the power and dimensionality of the crumpled white sheet.

GIVE ME A HOME
Mark Glover

(Right.) As in all minimalist drawing techniques, Mark's rendition of the famous song plays on simple defined forms to make a statement. The even tonal layers and the use of the drawing surface's tooth add to the sparkle and effectiveness of this drawing. The bright yellow fields, contrasting with the deep greens, appear brighter because they are sandwiched between a softer foreground and the lively, angular clouded blue sky.

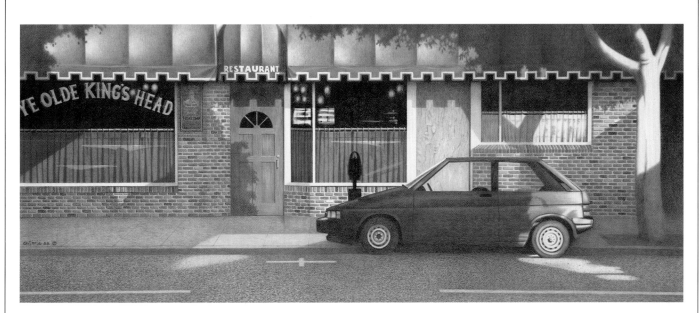

YE OLDE KING'S HEAD
Robert Guthrie

(Above.) The grayed shadow areas in this drawing by this well-known artist and author act almost as a frame, heightening the impact of the sunny areas. The fact that a grayed color tends to rest softly on a surface, rather than jump out to greet the viewer, allows the pure color applications to shine through brightly. Robert also has made use of saturated darks in the windows to heighten the impact of his gold-lettered title.

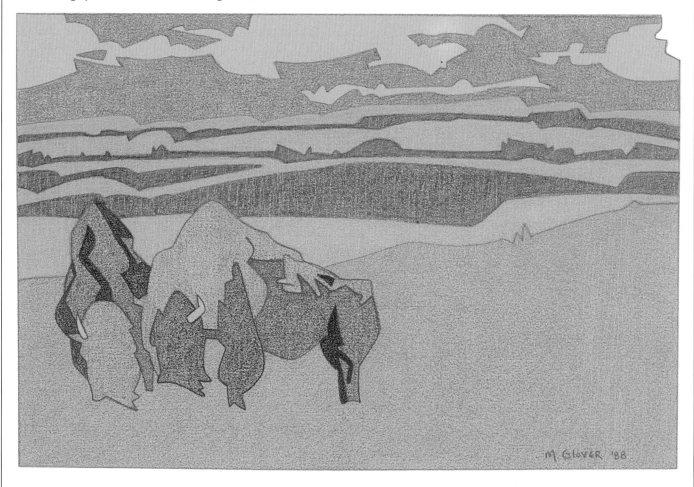

COLORED PENCIL TECHNIQUES

*EARLY SPRING WITH
MY FATHER*
Karen Anne Klein

To hold a colored pencil for the first time can be a frightening experience. What will it do? What *can* it do? The answer is simple: It will do what you want it to do; what you *will* it to do. Through practice and diligence, the pencil becomes the extension of your desire to render feelings, thoughts, and perceptions accurately.

Learning to manipulate the colored pencil is an exercise in control. It also is a medium that is free, expressive in its linear qualities, and powerful in its translucent depth and richness.

There is only one thing that every artist should avoid: *the easy way out.* In this day and age, there are those who would try to convince us that only the easy way will give us more pleasure. Actually, it only provides us with mediocrity and a false sense of having accomplished more than we really have. Colored pencil drawing is an exacting medium, one that demands patience and care. But it really asks of the artist only one thing: enjoyment. As with any other medium, colored pencil drawing must be nurtured. Artists must practice and learn the various techniques and discover their own unique approach to the medium.

Looking for easy ways to complete a masterpiece is a waste of time. There aren't any easy ways that produce satisfying results. Studying the work of professionals has been an honored technique for acquiring skills and sensibilities. In this chapter, as throughout this book, I have included the techniques and wonderful work of professionals from which you can learn. None of these artists has reached his or her level of competence through "easy ways out." Their skills have been honed over a period of time and through diligent practice.

One thing I have discovered through communicating with these fine artists is that they are all pleased and eager to share their techniques, interests, and enjoyment of the colored pencil medium.

So enjoy applying these techniques and discover the pleasure and pride at becoming better than you ever hoped. Remember, anything worth doing is worth doing well, and anything worth doing well demands a concerted effort. Concerted effort eventually yields not only good results, but most of all, it gives us personal satisfaction and pride.

Strokes: (Above.) The rendering process in colored pencils is similar to that of drawing in graphite. The basic elements are strokes, both short and long. Here is a series of short strokes used both to create texture and to cover a surface.

TALLY
Bernard Aime Poulin

The major portion of the wicker chair in Tally's portrait is made up of hundreds of short, curved strokes in white, mauve, slate gray, brown, and sky blue.

STROKES

The first impressions to produce are the shortest. These are called strokes. They can be straight, curved, angular, or jagged. Combining one stroke with others, it becomes evident that patterns can cover a vast area. The drawing surface becomes part of the process rather than simply a surface. Once you are comfortable with the possibilities of these short applications, it will be easy to extend them into longer and more intricate lines.

HATCHES AND CROSSHATCHES

Repeated long strokes are called hatches. These often lie parallel to each other and give the impression of forming a textured ground. When groups of parallel hatches are stroked in several directions, the formed pattern can be more intricately woven, intermingled, and overlaid with other hatches. This is called crosshatching. When crosshatches are created using several different colors, a richness of hue emerges.

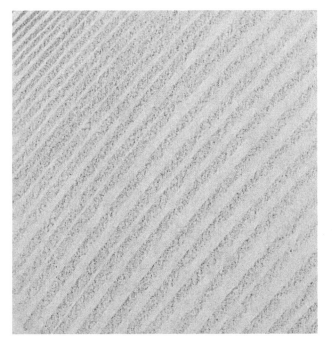

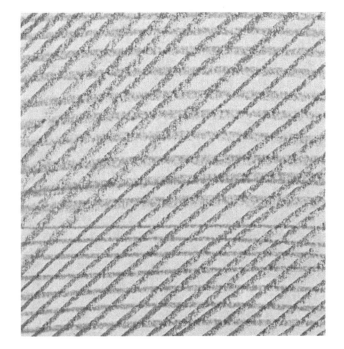

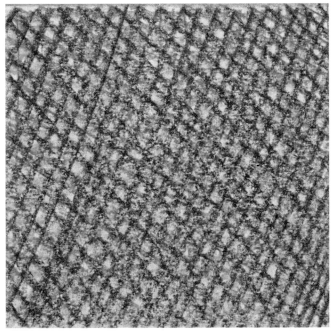

Hatching: (Above.) As strokes lengthen they are eventually called hatches. Hatches are a series of parallel strokes of varying lengths. They can be applied one next to the other for a block of color or more or less widely apart to allow the paper surface to show through.

Crosshatching: (Above.) As the name implies, crosshatching is simply hatching in one direction, then hatching over the first application in another direction. Crosshatching, and hatching, can be done with one or more colors to achieve various results.

Layered Crosshatching: (Left.) The process of crosshatching is not limited to two layers of hatching. Using a wide array of colors, crosshatching can be used to achieve myriad beautiful hues through the combination of accumulated hatches.

JULIE & TESS
Bernard Aime Poulin

Apart from the evident strokes in the grass at Julie and Tess's feet, the hatching and cross-hatching in the sweater give a good indication of the textural thickness hatching can produce. This is even more apparent in the contrast between the softer white of Julie's blouse and the thickness of the sweater.

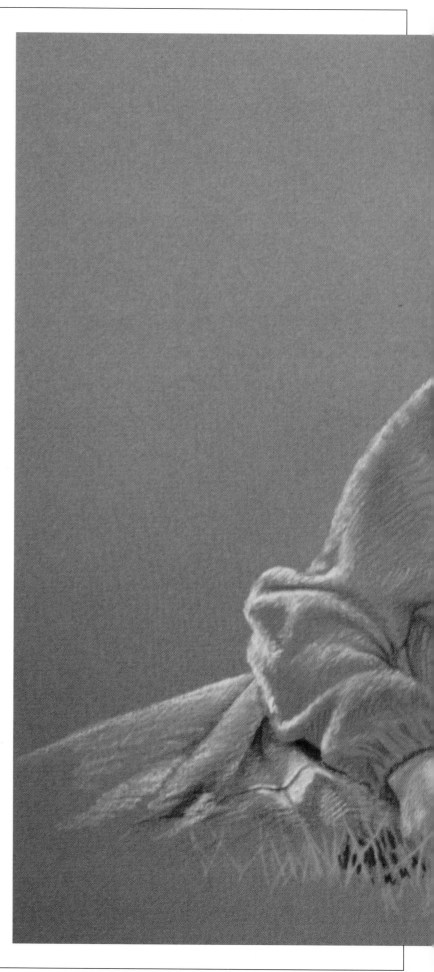

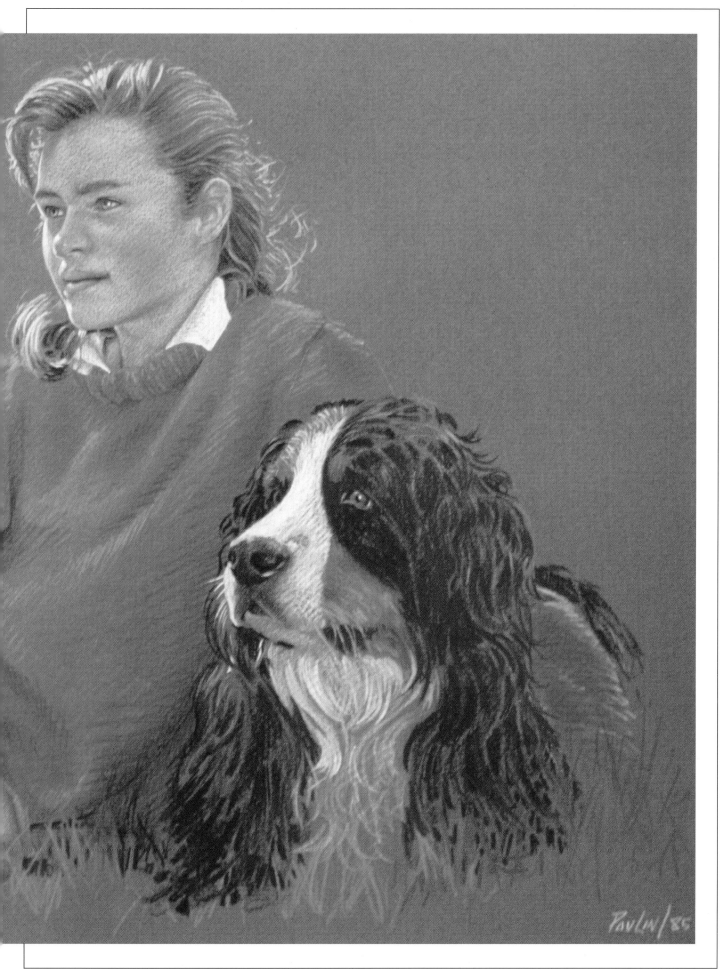

TONAL LAYERING AND BLENDING

It is also possible to apply an even layer of color by covering a surface shape completely with closely knit parallel lines. This is called applying a tonal layer. Once an even layer is completed, other colors can be overlaid. This is called layering. When two or more different colors are overlaid the result is a blend. Blending is the act of creating a new color through the intermingling of overlaid hues.

GRADATED TONAL APPLICATIONS

When a color is applied evenly it gives the impression of a flatness to the colored area. If a layer of color is applied with varying amounts of pressure—from light to heavy or from heavy to light—the impression is dimensional. The eye perceives gradation as a curve. The more gradual a gradation, the softer the curve. The more immediate the change from light to dark, or vice versa, the more acute the curve will be perceived.

Gradation: Tonal applications are achieved through a series of closely knit strokes that cover a whole area. Through gradation of the strokes—applying color with varying degrees of pressure—more softly or harshly sculpted forms can be achieved. Again, tonal applications can yield richer, more saturated colors by layering a first tonal application with further applications using different colors.

CLARA
Mark Glover

Tonal Layers: Mark's portrait of Clara is reminiscent of a woodcut with its wonderfully even, single tonal layers. This effect demands that the application of color be well controlled. The translucent quality of a woodcut also was achieved by Mark when he applied his tonal layers with medium, rather than hard pressure.

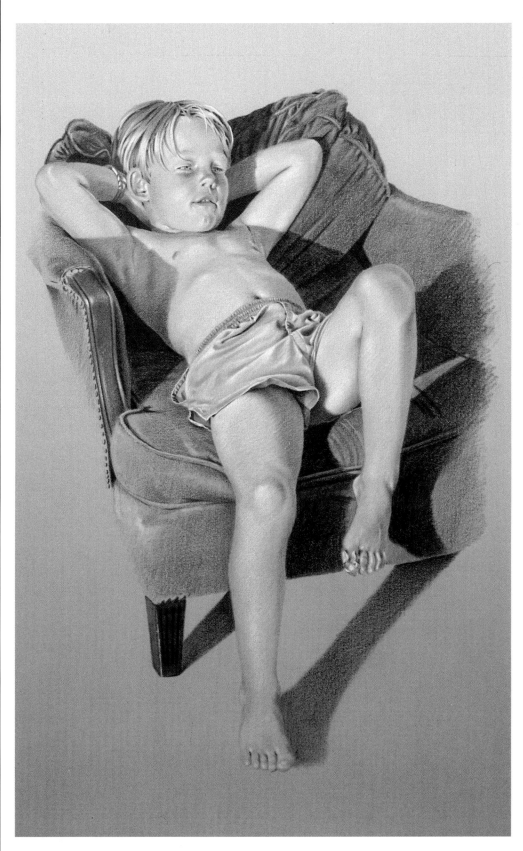

PRICE
Bernard Aime Poulin

Tonal Layers and Gradation:
Apart from Price's hair and the
brass nail heads, the portrait of
this boy was completed using
tonal layering and gradated ap-
plications. The texture of the
chair demanded less than total
saturation of the colors. There-
fore, light-to-medium pressure
applications were used. Render-
ing the wood armrest decora-
tions and the legs demanded the
use of heavy pressure applica-
tions in tonal gradations.

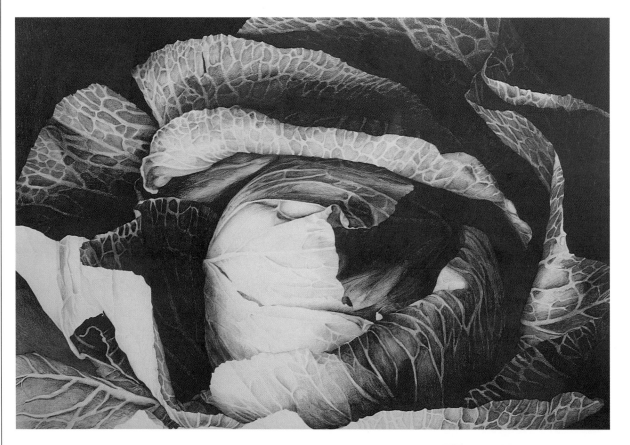

JUNE CABBAGE
Christine Fusco

Gradation: The curling leaves of the cabbage would not be as realistic or tangible if Christine had not gradated her tonal applications with care. To achieve such a high degree of flowing in and out, the artist had to be aware of all of the subtle values of green needed to give life to her very "tasty" rendering. Note the crisp edges of the leaves. This is a fine example of a complete tonal approach, rather than a linear one.

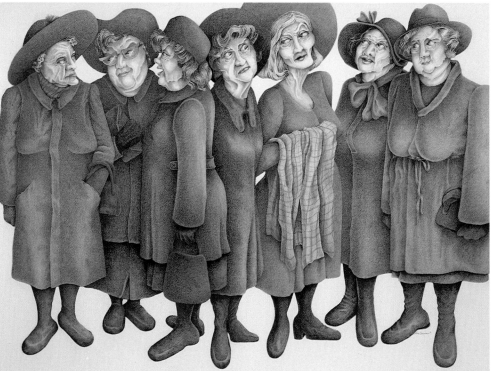

SOME ASSEMBLY REQUIRED
Vera Curnow

Blending: Vera's whimsical drawing of a group of women would be harsh if it were not for her knowledge of the medium and her respect for the subject. The blending and gradations of the muted colors, in the coats, hats, and boots not only works technically, but is in keeping with the intent of the artist — even the techniques used to render a drawing must be re-

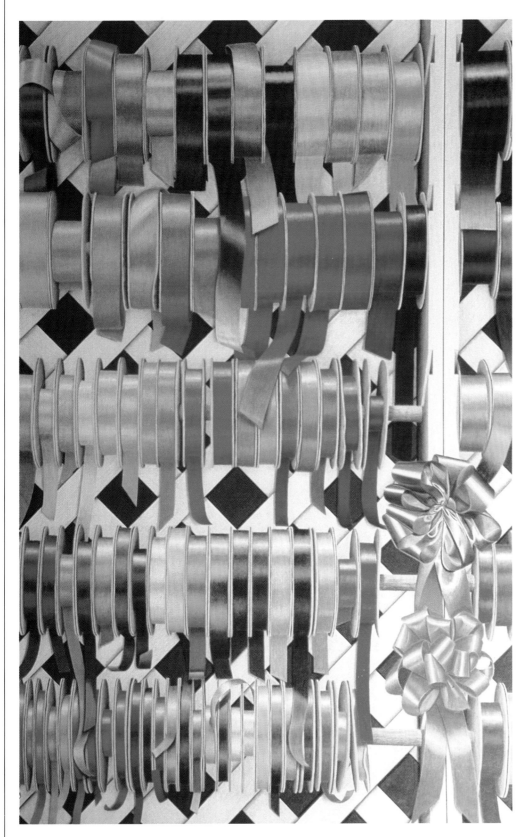

RIBBONS
Gary Greene

Gradated Strokes: A collection of ribbons is an obvious choice for an exercise in gradation. Gary Greene simply shows us to what height of success such an endeavor can be taken. Gradation not only defines the soft curve of each roll, it also emphasizes the texture through a carefully rendered and closely knit series of gradated strokes.

lated to the subject matter. Vera's work is whimsical because her treatment of the subject matter smiles *with* and not *at* the subject and the viewer.

BURNISHING

Burnishing is a method whereby a layer of light color is blended forcefully into the pigment of previously applied colors, blending them thoroughly in the process. The valleys in the paper are therefore completely saturated with color. The result is creamy smoothness that has a waxy look and feel.

Burnishing: As a rule of thumb, white is the prime burnishing color. Other shades, such as light flesh and lighter grays, are the next most-used burnishing colors. In fact, any color lighter than the hue to be burnished can be used for this purpose. The deeper the burnished color, the more impact burnishing has on that color. Note the difference in intensity in the samples to the right.

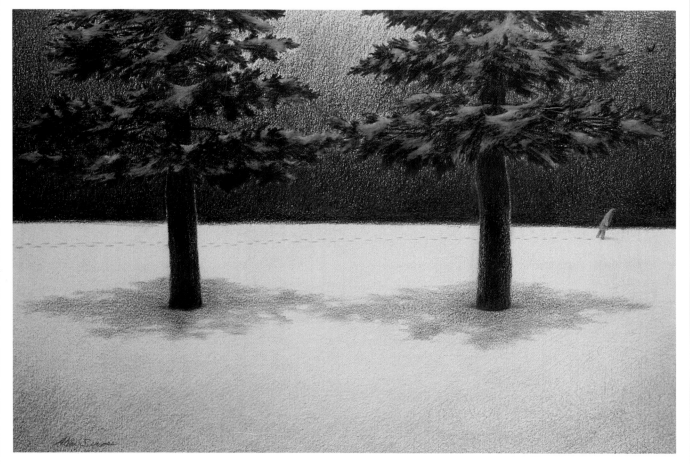

FROST MOON
Allan Servoss

This is a good example of the subtle use of burnishing. The snow-laden branches are made solid and heavy, creating an intriguing mood. The technique has not been overdone, as is sometimes the case with this method. Allan's simple, thick application of white over indigo is enough to convey the desired effect. Burnishing is an effective technique when used judiciously. Its main fault is the pasty look it can give a drawing when it is improperly applied. Practice makes perfect!

1940 PACKARD
Gary Greene

Knowing the shape, form, and flow of a subject definitely helps the artist render it accurately. Gary's *1940 Packard* is a fine example of the patient and accurate blending and burnishing of colors, using strokes that hug the flow and direction of the shape. Rendering highly polished paint surfaces is, at best, an extraordinary exercise. Rarely is it as successful as Gary's work displays. In blending colors to create a shiny surface, the artist must always account for the colors of reflections that blend into the local color of the subject.

SGRAFFITO

A knife, razor blade, or craft blade, such as the one made by X-Acto, is a useful tool. Not only does it serve the purpose of sharpening pencils, it also is useful as a drawing implement. By scratching out a pattern atop a series of layered colors, the lighter applications beneath will appear, giving a drawing added spark. This technique works best when applied to heavy layers of color. Warning: you must work slowly and patiently as damage to the drawing surface can occur.

IMPRESSED LINE

An invisible line or series of shaped strokes can be created by covering a drawing surface with acetate or onion skin paper and applying heavy pressure with a pointed object. When color is applied to the area in which the indentations have been made, the impressed lines will remain white (or the underlying color of the tinted paper). This method is useful for rendering leaf stems, lace, or any other texture or design. The indentations will retain the color of the drawing surface so long as no color is applied directly into the handhewn canals or valleys.

REMOVING COLOR

To remove a color completely, it is best to use a combination of blades and erasers. The process demands that you work slowly and gently as damage to the drawing surface is a real possibility. With any type of eraser, a small area of color can, with care, be removed quite effectively. Erasers also are useful tools for softly blending colors.

Sgraffito: (Above.) Sgraffito is the art of scratching out color to reveal the drawing surface or previously applied colors. In this example, several layers of heavily applied color are scratched into by using the point and the length of a blade. Prior to the use of sgraffito, a deep blue dominated the previous color applications. Scratching out portions of the blue has revealed the previously applied red, yellow, and orange colors.

Impressed Line: (Above.) The object used to impress a line should be pointed enough to indent, but not so pointed that the overlay is torn and the underlying drawing surface damaged. Practice makes perfect with this technique. A less-than-sharp point of a pencil or a ballpoint pen that has run out of ink are good impressing tools, as are fingernails or any pointed implement.

Erasers: (Above.) Here are some of the kinds of erasers I use. You can see where I've used the kneaded eraser softly to lift off some of the blue-violet color.

DRAWING TECHNIQUES

A friend's son has a fascinating room in his house in Bermuda that is filled with all of the things teenage boys find interesting. I have painted both of Stevan's windows, which are unusual and attractive. I used Berol Prismacolor pencils on four-ply board to produce my rendering of *Stevan's Other Window*.

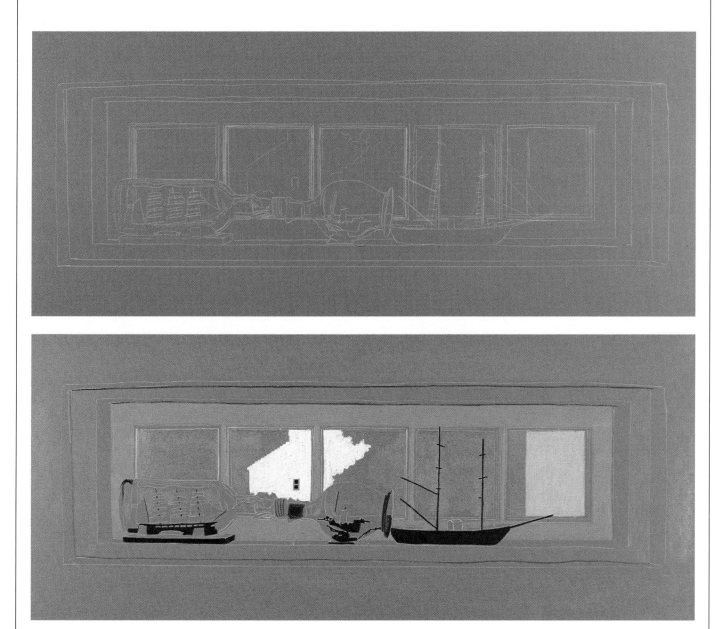

Step One: (Top.) I completed my final sketch of *Stevan's Other Window* on a sheet of standard drawing paper. After chalking the back of the sketch, I placed it over a medium-tan, four-ply acid-free board and traced the lines I wanted to retain, including those that defined the shadow areas and reflections. I then refined my lines with a white Prismacolor pencil.

Step Two: (Bottom.) Using #912 apple green, I applied a medium-pressure tonal layer to the foliage in the background. Heavy pressure on #938 white was used to define the white cottage and #939 flesh to indicate the pink stucco wall. Indigo #901 was then applied with heavy pressure to all the darkest areas in the drawing, including the far-off window of the white cottage. Slate gray #936 was applied in tonal layers to the interior wall of the room (light pressure), the window well (medium pressure), and the window frame (heavy pressure).

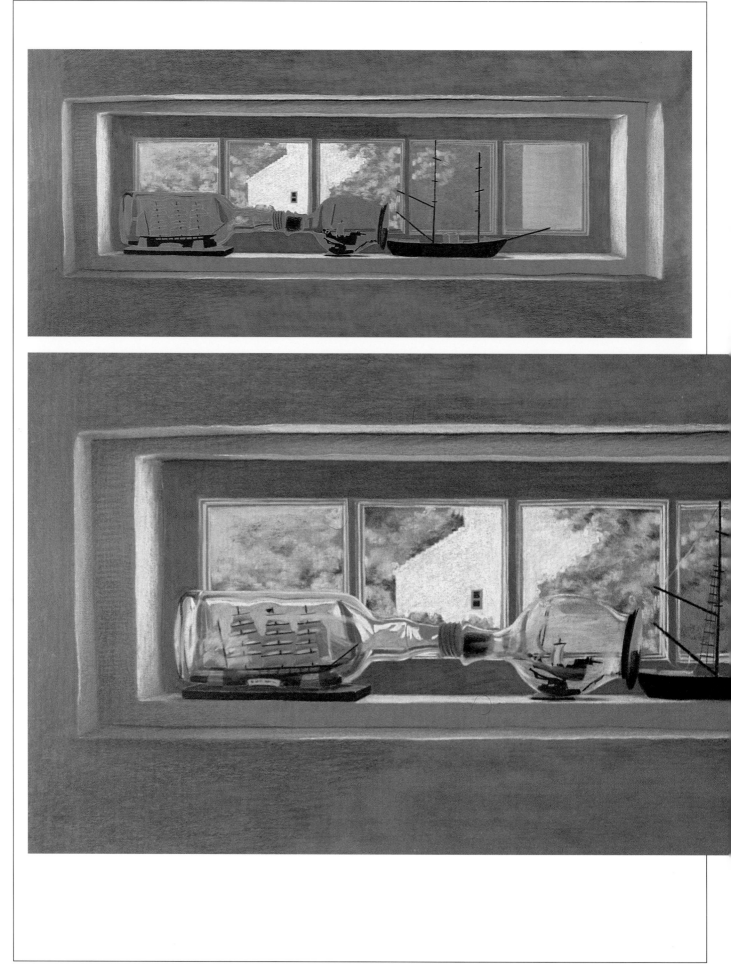

Step Three: To infuse atmospheric color to the outdoor view, a light tonal layer of #912, a medium green, was applied. With a #913 green bice art stick, I burnished irregular shapes into the foliage to indicate highlighted areas. Light to medium overlays of #941 raw umber were then applied to the wall, window well, and window frame.

The distorted shapes of the window frame, seen through the ships' bottles, were also indicated using #936 slate gray and #941 raw umber. Medium highlights along the window's surfaces were layered in using #927 light flesh. The strongest highlights were created using #938 white.

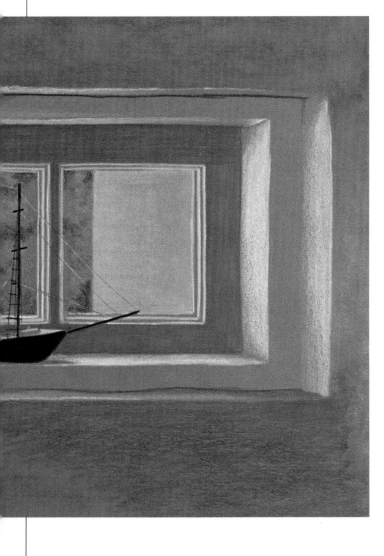

Step Four: The deepest shadows in the foliage were then added, using #908 dark green. Highlights around the windowpanes and within the ships' bottles were indicated using #938 white. Details, including sails on the small ships and the bottle caps, were indicated using #943 burnt ochre and #940 sand. Light flesh #927 and light aqua #992 and burnishings from a white art stick completed the outstanding highlights on the bottles. A last tonal layer of #941 raw umber was applied to the stucco wall and window frame. A pink reflection from the outside wall appears on the bottom of the bottle in the middle. This small detail is necessary to give the overall rendering an authentic touch.

ADVANCED TIPS AND TECHNIQUES

AUGUST ROSE
Christine Fusco

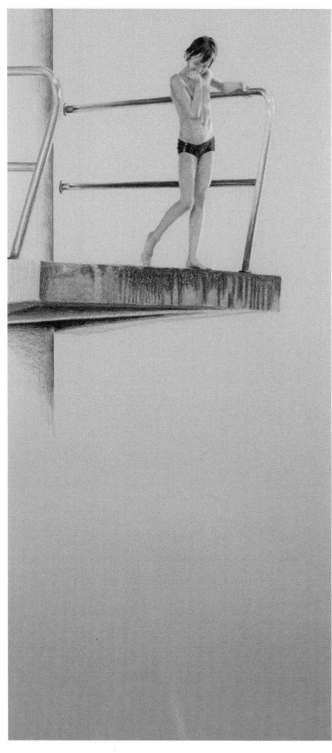

HESITATION
Bernard Aime Poulin

Despite the fact that spending hours with colored pencils is pleasurable, problems do arise. Most of these can be avoided with a little bit of foresight.

PROTECTING YOURSELF

Each of us has our own particular way of getting down to work. Choosing a comfortable drawing position should be considered, or after a few hours of drawing, our backs will remind us that we have overdone it. It is therefore important that chair and table are at the proper height and angle to meet our needs.

Carpal tunnel syndrome sounds ominous and it is (I suffer from it). When the same muscles and tendons of the hand and wrist are overworked, they can react, creating a very painful and debilitating injury. This problem has become almost epidemic with computer operators, musicians, *and* artists. It pays to be kind to the tools of your trade!

Our eyes also are important. Good lighting is a must when pencil drawing. Straining those vital organs is a no-no.

Working despite injuries: I recently injured a thumb by grabbing a falling drinking glass with too much pressure: The glass broke and my thumb needed six stitches! I needed to work and the only solution was a "banker's thumb." This is a rubber thumb cap, available in any office supply store. The cap comes in different sizes to fit fingers or thumbs, and has air holes to allow breathing of the skin. It saved the day! I was able to work despite the stitches.

PROTECTING YOUR ARTWORK

Once you are reasonably sure you are well protected from injury, the next step is to protect your drawing surface. Paper and boards are sensitive to pressure and can be damaged at the most inopportune times, such as near the completion of a superlative drawing.

The simplest way is to protect the surface before you begin. Removing any rings, watches, other jewelry, or even shirt-cuff buttons is a must. These objects gouge and indent surfaces and yield surprising, though unwanted results when color is applied. The damage attracts more attention than all of your great efforts. Impressed lines are a legitimate technique, but not unintentional ones.

A clean blank sheet of inexpensive newsprint is an effective way to keep your hand and arm off the sensitive drawing surface. Small slivers of color from pencils

can easily be ground into areas where you do not want spontaneous color applications. To prevent this, add to your tools a two-inch-wide painter's brush to periodically rid the drawing surface of shavings and slivers. These inexpensive items are a must for a well-stocked studio.

If you work on fairly large paper or board, it is advisable to build an armrest.

OTHER TECHNIQUES

The colored pencil is a very flexible medium, blending well with other mediums, such as air-brush, watercolor, acrylic, ink, and solvents. On the following pages are examples of some of these special techniques.

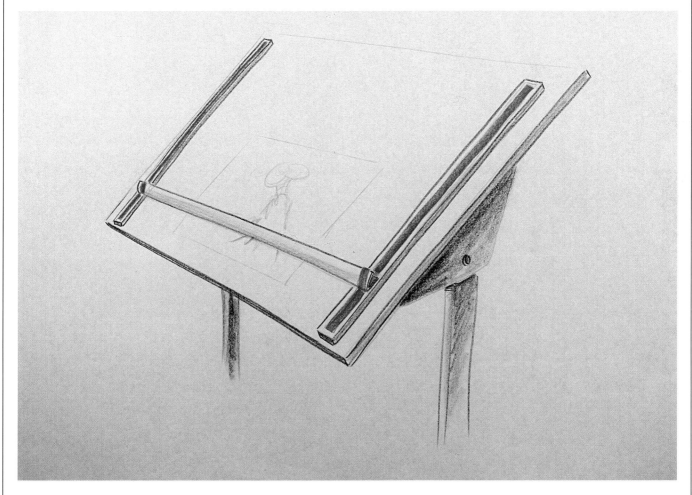

Armrest: An armrest that bridges the drawing surface must be strong enough to support the weight of your arm. Mine is a simple apparatus, made even simpler through the use of Velcro. After renovating my kitchen, two long half-inch boards were left over. I cut them to fit the height of my drafting table and then stapled Velcro strips to the whole length. From a hardware store, I obtained a five-foot strip of V-shaped aluminum. Its shape gives it enormous strength, even when weight is applied to the unsupported middle. To each end I taped Velcro strips. Now I have a movable support that can be set high or low according to my needs. The total cost was about $20.

A simpler version of an arm support is a painter's mahlstick. Its rubber tip holds the stick firmly in place. One drawback is that your other hand is occupied supporting the stick, rather than assisting in the drawing.

DEMONSTRATION
WATERCOLOR AND COLORED PENCIL

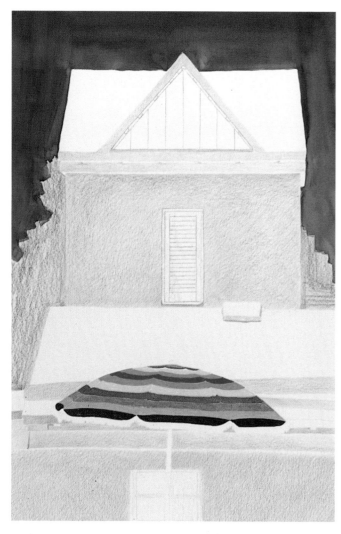

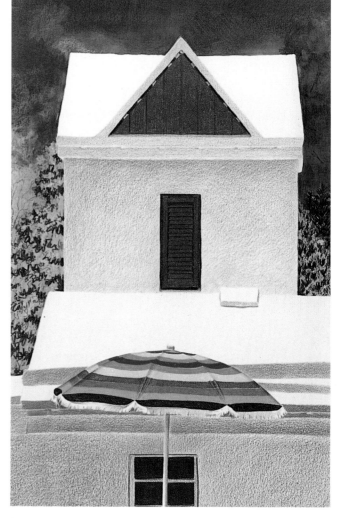

Step One: In this rather graphic rendition of a Bermuda scene, I applied watercolor to the sky portion, while adding light tonal layers of sky blue to the shadow areas of the white house. Olive green was applied in a scattered tonal layer to the foliage on either side of the building. Then, the rainbow-colored parasol was colored with heavy applications of red, yellow, orange, blue, and green.

PARASOL
Bernard Aime Poulin

Step Two: I then burnished the watercolor sky with white. Using a bottle green pencil, I added dark linear accents to the foliage, inserting a few additions: dark trees with indigo blue to the right and against the sky. Peacock green was applied in heavy layers to the pinnacle and the shutter. These areas were delineated with indigo blue and tuscan red. The window below the parasol was filled in with heavy layers of tuscan red and indigo blue. Then, the luminous shadows on the walls of the house were overlaid with a light treatment of orange and with more sky blue. To complete the drawing, I added the details on the parasol's fringe and its canvas umbrella.

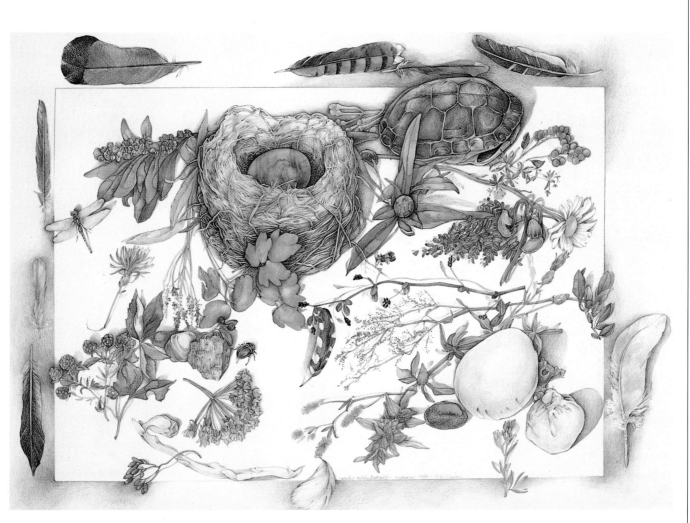

WALKS WITH BARRETT
Karen Anne Klein

Watercolor and Colored Pencil: Karen Anne uses watercolors to lay a transparent foundation for her drawings and then textures over with colored pencil applications. The result is reminiscent of a sketching notebook page or a page from a botanist's diary. It's very effective at evoking a mood of tenderness.

Colorless Blender: This tool is basically a felt-tip marker with no color. The solvent blends with colored pencil pigment and intensifies the colors. A blender can also soften the effects of color layers without affecting the tooth of the drawing surface. Its only drawback is that its strokes resemble color applications of a marker.

PLEASANT RIDGE BACKYARD
Karen Anne Klein

Controlled Strokes: It appears as if the subtle blending of colors in this drawing could have been done with a colorless blender, an eraser, or by burnishing. Actually, Karen Anne spent a year or so working on this drawing to achieve its beautiful softness. She used no unusual techniques—just controlled strokes and many layers of colors.

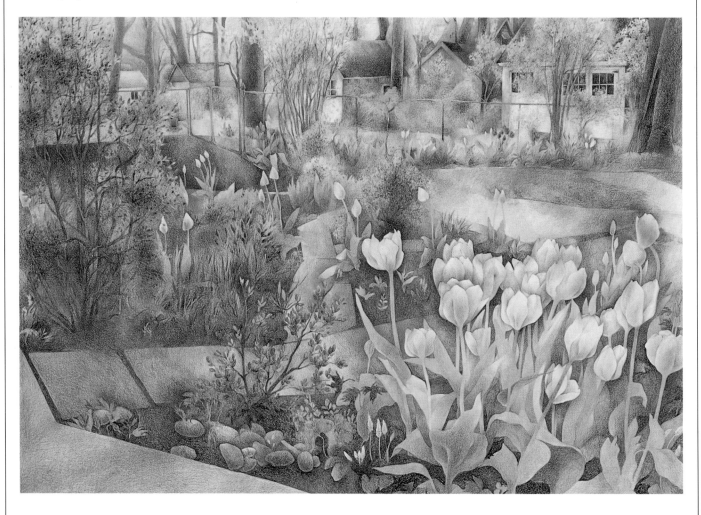

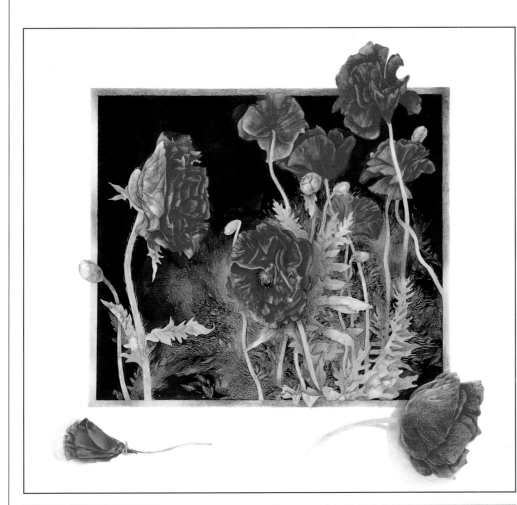

POPPIES
Karen Anne Klein

Black Ink and Colored Pencil: The rich velvety texture of the black ink background heightens the impact of the colored pencil poppies. Their stems and petals literally jump away from the background. Strong strokes abstract the fernlike foliage in the background, heightening even more the poppies' powerful stance.

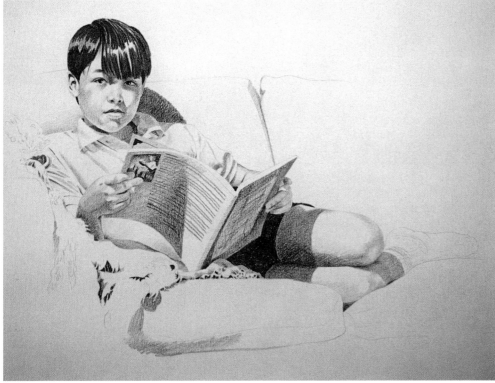

DANIEL
Bernard Aime Poulin

Grisaille (Imprimatura): Dating back to the seventeenth century, imprimatura is a method whereby the artist tints the drawing or painting surface before beginning color work. *Grisaille* (pronounced greezeye) is the French term for imprimatura, which is Italian. If you use a tinted drawing surface, you are already using a form of this technique. In Daniel's portrait, not only is the drawing surface tinted, but the figure itself is monochromatically complete prior to the addition of further colors. This illustration of the drawing shows only the first stage. The next step would be to warm up the indigo drawing with an overlay of tuscan red, completing the imprimatura. Once this is done, color is added.

ANDREW AND THE STATUE OF LIBERTY
Ken Raney

3-D Effects: Simplicity and defined clarity are the keys to successful three-dimensional qualities in one's work. Ken has produced a wonderful piece that appeals both to children and to the child in all of us. The misty grayness of the background and the simplified rendition of the statue provide an airy, dreamlike atmosphere in which Andrew and his "horse" can fly to points known only to him and the viewer's imagination. The strong highlights contrasting with the background add to Andrew's realness in a world of dreams.

ON THE PORCH
Ken Raney

Toned Paper: Ken has transformed the toned paper into a soft, shaded background for his subject. The applied highlights and cast shadows enhance this illusion, as does the general soft tone of the whole picture.

HOW TO DRAW FROM A PHOTO OR SLIDE

Using photographs as reference material is not new. Some of the Impressionists and other artists in the last century made good use of photographic material to aid or expand their visions.

The problem is not that photos or slides are used but rather that they often are used badly. Copying a photo exactly often will yield an image that is much less a work of art and much more a simple copy of a picture which would have been better off remaining a photo.

Photos and slides can offer too much information which must be examined and culled before a successful drawing can be created from them. It is necessary to eliminate some of the excess information. Taking the time to study a photo and make notes about what must be ignored or eliminated will help tremendously in the composition of a drawing.

Many snapshots have too much background, which tends to overpower the focal point. This can be too easily translated into the drawing, creating a similarly unacceptable rendition.

The first thing to do is examine the photo with one thing in mind: What is it in this photograph which makes it exciting (the reason why I am using it in the first place)? Once this has been decided, everything else plays a supporting role in the finished product, or else detracts from the impact of the main event.

Next, what is extraneous in the photo? What can I take away without damaging the impact? This I can decide through thumbnail sketches, which will help me evaluate my observations. The following illustrations will help explain more fully what I am saying.

Tracing from photos or slides: If you want to kill your ability to draw accurately, depend solely on the "tracing directly from photo" method to achieve accurate and swift outlines for your drawings. The results often are so accurate they are boring and lifeless. Be careful of this easy way out. It may be the beginning of the end for you.

Idea Photo: While on a recent trip to Bermuda, I shot this photograph of runners struggling up a hill. The crowds were encouraging the runners. I thought I could get some ideas for a drawing from this photo.

Thumbnail One: My first sketch highlighted the struggle of the runners and the jubilant crowds. After completing this sketch, I realized that too much was going on that interfered with what I wanted to say. I had already chosen to eliminate one of the runners, a telephone pole, wires, and some of the background, but I was still not sure what I wanted to draw.

Thumbnail Two: As I worked, I began to think of the runners, rather than the scene I had witnessed. I tried to comprehend their intensity, their lone struggle. I realized that despite the enthusiastic crowd, running was a solitary challenge. My sketch suddenly became less crowded. I accentuated the hill. I increased the idea of distance by adding runners in the background and eliminated another runner from the foreground to increase the feeling of solitary pursuit. Finally, things began to fall into place.

Last Sketch Before Finished Drawing: I was becoming excited. My first idea had been altered and altered again. I had cleared my mind of all the extra information the photo was giving me. All I had to do from then on was intensify the impact of my idea through a study of tonal values and color applications.

Details: As in any other drawing process, it is best to establish the large shapes and spaces in the beginning and concentrate on details near the end of the drawing. This is difficult to achieve using photos as they tend to stress so many fine details. The tendency is to copy it all down without realizing it.

Squinting and masking: Squinting at the photo in the beginning will help you concentrate on the large shapes. You can also mask out areas of the photo that are disturbing by cutting a hole in the center of a piece of cardboard. This allows you to see only the area you are working on.

Collage: By using a utility knife, you also can cut out any important details in the photo. This permits you to move the pieces around on a neutral surface, thus creating your own composition, as in a collage.

Distortions: Photos also have a tendency to exaggerate the size of an object closer to the lens; for example, the feet of a person whose legs are stretched out towards the lens. Unintended use of distorted proportion assures the viewer that you are completely dependent on the photographic image. Exaggeration can be a wonderful technique, but only when it is warranted.

Edges: Edges in photographs are often quite crisp. Edges must at times be softened in order to create a tangibly realistic image: separate, yet part of the ambience and background. It is therefore important not to copy literally from a photograph. Not being aware of this will make your drawings static and give the impression that the main subject is not truly part of the background and has been "cut out" and pasted onto your drawing surface.

SLIDES

Slides suffer from the same drawbacks as photos, yet they also can be useful tools in the drawing process. Slides allow you to blow up an image to life size, giving you a better perspective on the actual subject to be sketched. This use of photographic material demands that you have a separate light to illuminate your work area while the slide image remains in the dark. This can be annoying. To solve this problem, you can use a reverse screen.

Reverse screen: A reverse screen is simply a semi-opaque screen that receives a projected image on one side and displays it crisply on the opposite side. Such a screen is available at your local photo supply store. It can be cut to size and purchased by the yard.

This thick plastic screen can then be stretched on canvas stretchers and hung above your drawing table. A regular drawing light can be used without fading the projected image.

Note: The projected image is very crisp but reversed. You will have to put your slide backwards in the projector to work from the correct image.

One advantage with slides is that you can project them slightly out of focus, thus eliminating fine details that may hinder your laying out of the large shapes. This procedure also helps you see the shadow areas more accurately.

When difficulties are encountered in rendering, you can go around to the opposite side of the screen and view the image "reversed." This helps you define the problem areas more clearly. This is an adaptation of the mirror image used for centuries by artists for the pur-

Reverse Screen: This shows a reverse screen being used in the studio.

pose of discovering errors and trouble spots in a drawing or painting.

CAMERAS

Even when not taking actual pictures, a camera can be a great help. On location or in the studio, you can look at your subject through the viewing screen of a camera to define the parameters of a composition. The added feature of a telephoto lens lets you change the distance, composition, and subject matter with a twist of the lens.

BLACK-AND-WHITE VERSUS COLOR PHOTOGRAPHS

Black-and-white photographs are much better at defining subtle values than colored photographs. Color often distracts us from realizing the true presented values. Black-and-white photos also define sharp and soft edges more readily.

Often color photographs or slides are not accurate in the rendition of color. This may be due to the improper choice of films. Photo color often pales in comparison to reality, or it is greenish or bluish or too warm. Depending too heavily on photographic reference material can cause problems in color choices.

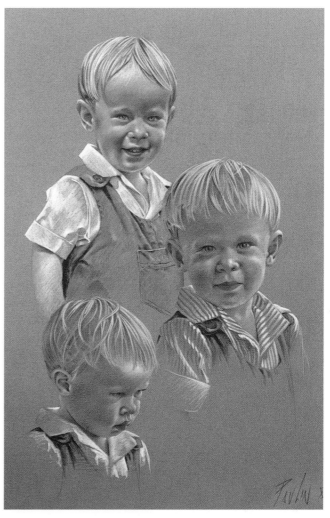

STEVEN
Bernard Aime Poulin

Another area in which photography can be useful is when drawing young children. Children rarely hold still and can change expressions from one moment to the next. Sketching from photos can never replace the knowledge and skill acquired from life drawing, but photographs sometimes can be essential when planning a finished drawing.

PRACTICE
Bernard Aime Poulin

In some instances, like catching the action of piano practice, photography is a necessity. The important thing is to use photographs as reference materials to support your own artistic statement.

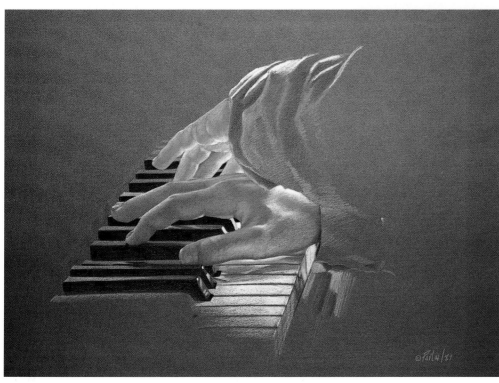

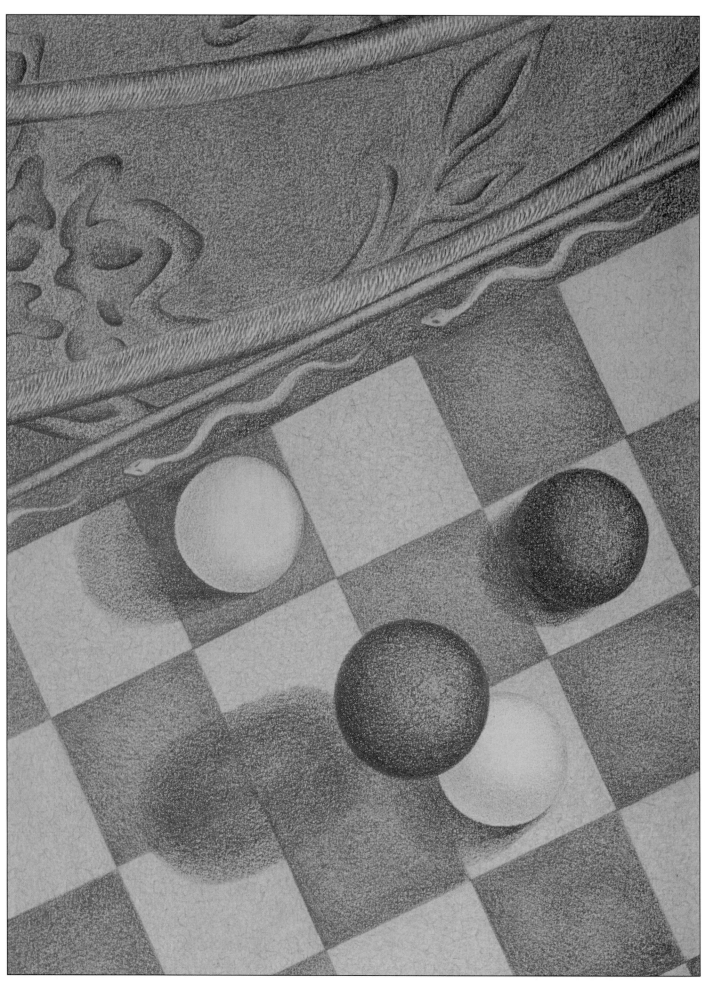

CREATING TEXTURES

COSMIC CHESS, detail
Nikki Fay

The subject of your colored pencil drawing should determine the choice of drawing surface to be used. If, for example, a stone garden wall is the main element in your rendering, your choice of paper or other surface could be rougher than a surface needed for the soft rendering of a baby's skin.

Other tools, such as pencil or stick, watercolor base or acrylic, also will be determined by the main subject matter. All subordinate details in the rendering should conform to the surface requirements of the main subject. By using various pressures and points, as well as various application techniques, all the elements of the picture can be rendered harmoniously, even if the texture of the main subject has been created by the simplest application technique. The focus of the drawing should always be paramount; subordinate or "supporting cast" matter should never overpower the main subject.

The following information is presented as a compilation of hints. There are many ways in which to render textures. These techniques have proved useful in the past. I hope they can make your colored pencil drawing more pleasurable.

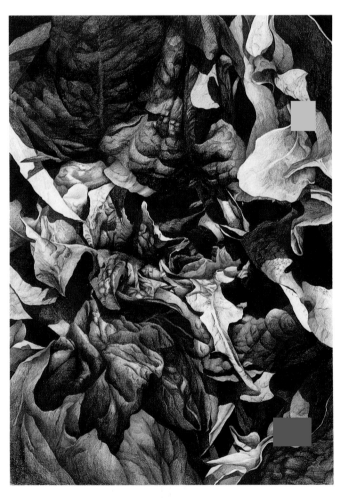

HEAVY LETTUCE, detail
Christine Fusco

Old Wood: To render old wood, study the grain pattern; each type of wood has its own unique grain. Old wood has usually grayed, and its surface has become gouged and wrinkled. Cracks are evident due to the drying out process. Apply a medium tonal layer of light blue and overlay it with a similar layer of raw umber. This will age the wood texture and give it its flat, lifeless quality. A heavy tonal layer of sepia should then be applied. Knots and grain will appear when sgraffito scratches are used to give the wood its indented and aged look. Final detail can be added with a pointed black pencil using heavy pressure.

Rocks: Rocks are impressive subjects and, unless the main subject of a drawing, should be rendered with more emphasis on mass and texture than on a rich layering of colors. Rarely are rocks gray or brown. Rocks feel solid and heavy when solid strokes are used to render them. Colored pencil sticks are good tools to delineate rock formations, and crosshatching colors works well for establishing shadows. Details of cracks and crevices should be downplayed. Rocks "breathe" more easily in their natural environments, such as in grass and reeds.

Bricks: Using a textured paper will help define a brick's texture more easily. Studying the many colors of bricks will help you choose colors to render them more tangible. I have purposefully exaggerated the thickness of mortar between the bricks to show that drawing bricks is not so much showing the flat expanse of clay as it is defining the bricks through the shadows created by the bricks' elevation on the mortar. By squinting your eyes, you will see that the bricks do step out of the flat paper. Without shadows, bricks lie back lifeless.

Stones, Gravel, and Sand: Even the smoothest of papers or boards has a texture. Establishing a tonal layer using the side of a colored pencil stick is the easiest way to render sand, gravel, and even stones. The texture will establish where the stones are, especially if you drag the colored stick over paper placed on a textured tabletop. By keeping the ground layers simple, stones of various shapes and sizes can be given more prominence through heavier-pressured applications. Remember that stones on the ground are noticeable because each casts its own miniature shadow. Establishing shadows is as important as defining the stones themselves.

Grass and Reeds: Grass, like hair, is often a difficult subject to render. That's because we unconsciously try to draw each blade of grass. To avoid becoming frustrated, follow these easy steps: (1) Establish the middle value of the mass of grass to be rendered. (2) Use a colored stick and with heavy pressure apply the tonal layer. (3) With a darker colored stick, establish the dark shadows in the clump or field of grass. Use medium to heavy pressure. (4) This done, use a razor blade or utility knife and, beginning at the base of the blades of grass, scratch upward and away from the paper. The lighter parts of the grass blades will appear. With reeds, it's better to establish the background and then scratch out the long linear reeds when you are adding the last details to your drawing.

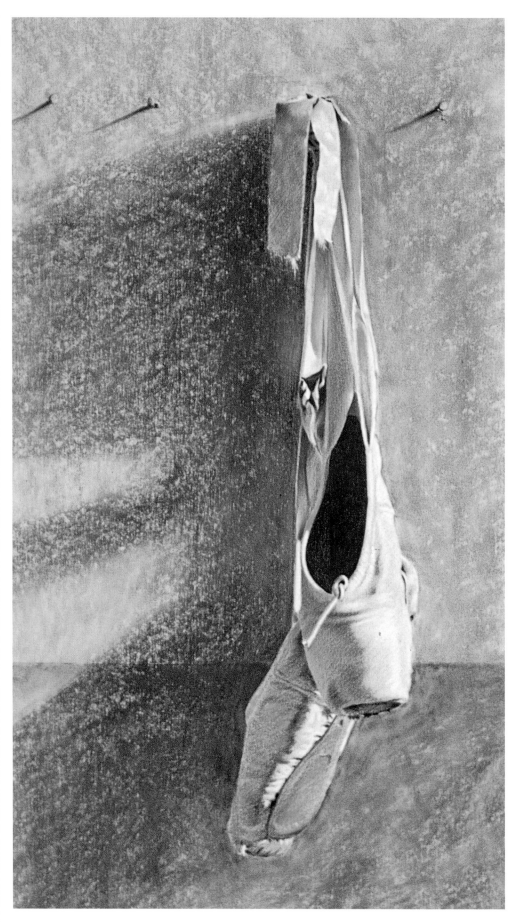

LAST PERFORMANCE
Bernard Aime Poulin

Painted Cement Walls: (Left.) Drawing ballet slippers is a challenge, especially when their silk texture contrasts with the milky texture of an old cement wall painted over many times. With heavy layers of colored sticks I "painted" the old wall, blending several gray-green colors to achieve the right effect. The shadow on the wall was warmed with medium pressure applications of purple, again using colored sticks. All light areas were burnished with the blunt end of a white colored stick. The soft, worn ballet slippers were rendered with colored pencils using light to heavy tonal layers.

JUST A LITTLE PRICK
Vera Curnow

Translucent Plastic: (Right.) The more plastic or rubber is stretched, the more it becomes translucent. Such a texture demands perfectly controlled tonal layers, using various pressures. Edges must be crisp and show no delineation. Any shapes seen through the stretched material must be muted, like the translucent object itself. The shaping of translucent plastic or rubber depends heavily on colors that blend into the object or are reflected by it. Highlights delineate the form, rather than lines around the perimeter.

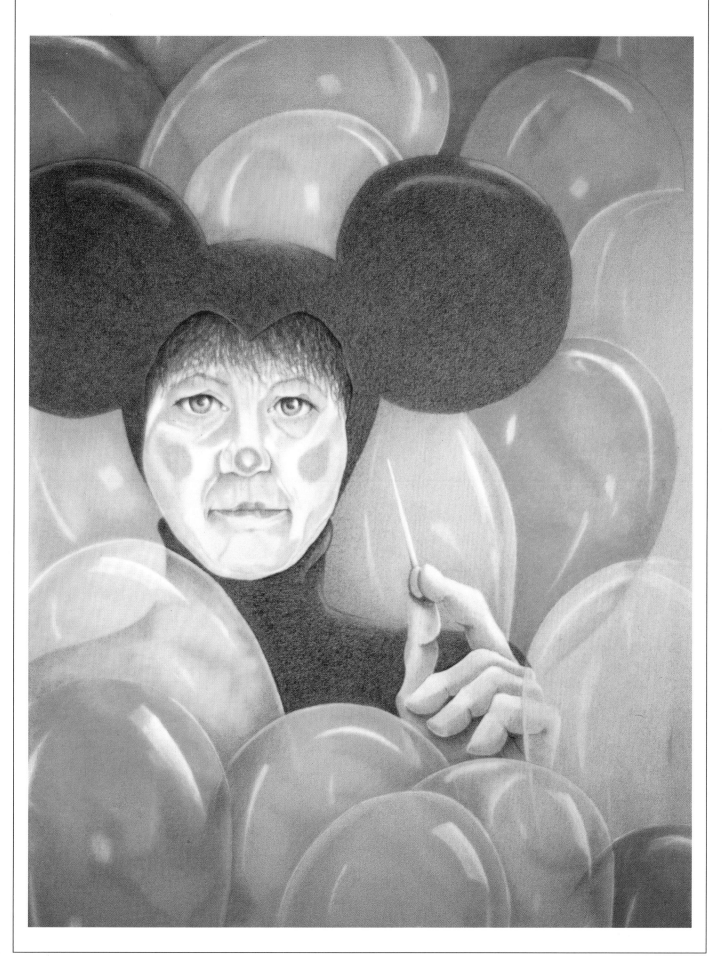

'50 BUICK
Gary Greene

Metal Surfaces: Gary is a master at shiny metal. His rendition of this Buick is classic, to say the least. Two examples of metal are evident here. The painted surface of the car denotes a need for very gradual soft edges and gradations, as well as completely even layering and blending that emphasize the curve of the hood and the texture of the paint. The secret to successful rendering of chrome, brass, copper, silver, and gold is in the ability of the artist to capture the subtle variations in the abstract values reflected in the shiny metal. Note that the edges of each abstract shape forming the various parts of the bumper are almost crisp. The nearer an object to the shiny surface, the sharper the edges of the shape being reflected.

SPEEDWAY
Robert Guthrie

Puddle: The one big difference between a puddle and a pond or lake is that the dry land edging the puddle is below the waterline, rather than above it. This means that the far edge of the pond has a defined diagonal or vertical definition. A puddle, on the other hand, lies on top of a flatter surface. In Robert's drawing, we can actually see the humid evaporation areas surrounding the puddle on the pavement. To achieve an almost rippleless reflection, a mirror image of the reflected objects must be created with precision. The only difference between the real buildings and objects and the reflected objects is that the reflections are slightly darker. It may sound simple, but these hints are the key to a successful reflection and puddle rendering.

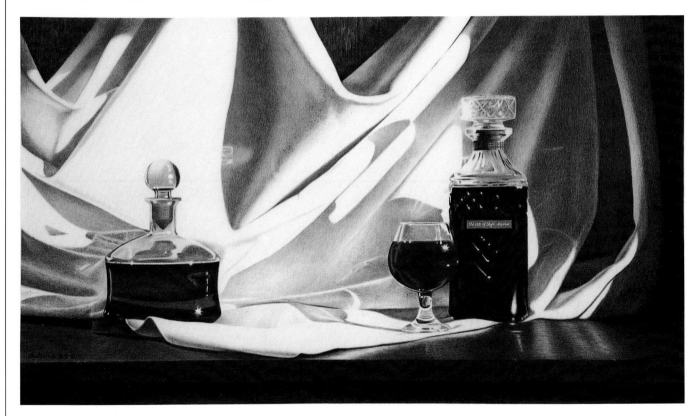

MORNING LIGHT
Robert Guthrie

Glass: Like metal, glass exists as we see it because of the light and color it reflects. Glass, whether transparent or translucent, depends also on light and color and shadows that sit behind or are contained within it. The texture of the glass containers also depends heavily on the liquids they hold, the distorted shapes caused by the glass's almost invisible curved shapes, and the light striking the surface of the glass. Where the liquid does not cause the colors seen on and through the glass, the background folds of the cloth take over. Note the cool grays that form the glass stopper and upper parts of both containers. The translucent liquid also permits light to pass through and reflect itself onto the background folds. Rendered on Mylar, Robert's colors are beautifully saturated, giving the whole piece the crispness of morning light.

PETALS
Gary Greene

Petals and Leaves: Gary's drawing is a true tour de force. He obviously loves flowers. The main secret to creating flower petals and leaves that are realistic is *no visible delineation*. Colors must reach right to the edges and remain pure. Leaves and petals are sensuous wafers of softness, and the tonal layers, gradations, and blending must take this into account. To achieve natural-like colors of various flowers, it's necessary to know which colors will truly convey the velvety feel of petals and the deep richness of leaves. Even the deepest values in flower petals must remain luminous. Studying individual flowers is a must before undertaking a Gary Greene masterpiece.

WATER-COLOR
Gary Greene

Multiple Textures: As the title of this work implies, Gary wanted to render the fascinating color of the water created by the resting sailboard. Intellectually, we know that water is blue. Visually, it rarely is so. Through evenly applied tonal layers, Gary has dispelled the myth that colored pencils are simply linear technique tools. The care with which this semiabstract drawing has been rendered also displays the artist's ability to use a technique of layering that respects the texture of the subject matter. The three main elements of board, sail, and water are unmistakable, though all three were rendered using hard edges, soft edges, gradation, and smooth layering.

SUNDAY AFTERNOON
Bernard Aime Poulin

Wavelets: (Above.) This drawing is not about waves, so much as it is about the child's lazy enjoyment of them. The waves are, therefore, secondary to the floating main subject. They have been rendered in a less-defined way. This was accomplished by applying medium pressure on indigo and purple pencils so as to permit the drawing surface to show through and give "sparkle," even to the dark shapes. As well, this looser definition of the wavelets makes them recede.

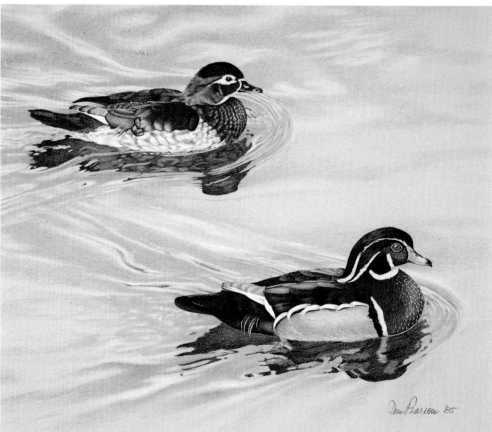

COSMIC CHESS
Nikki Fay

Similar Textures: It's possible to create a drawing where all of the included subject matter is textured in a similar way. Nikki does a beautiful job of separating similar textures. Through the use of shadows, gradated tonal applications, and slight variations in strokes, she has successfully given life to all of the elements. The spheres seem to float, even though they are visibly textured in the same way as the background surfaces.

WOOD DUCKS
Don Pearson

Water and Reflections: (Left.) Again, the waves in this drawing are not the main subject, but their participation in the success of the rendering is more direct. Waves created by a slowly moving object have their own way of forming and curving. Their softness denotes tranquility and gives the drawing its mood. Rendering this type of wave demands light-pressure tonal applications with very subtle gradations and soft edges. Note that the reflections are darker than the ducks causing them. Since the water is gray-blue, the reflections are, too.

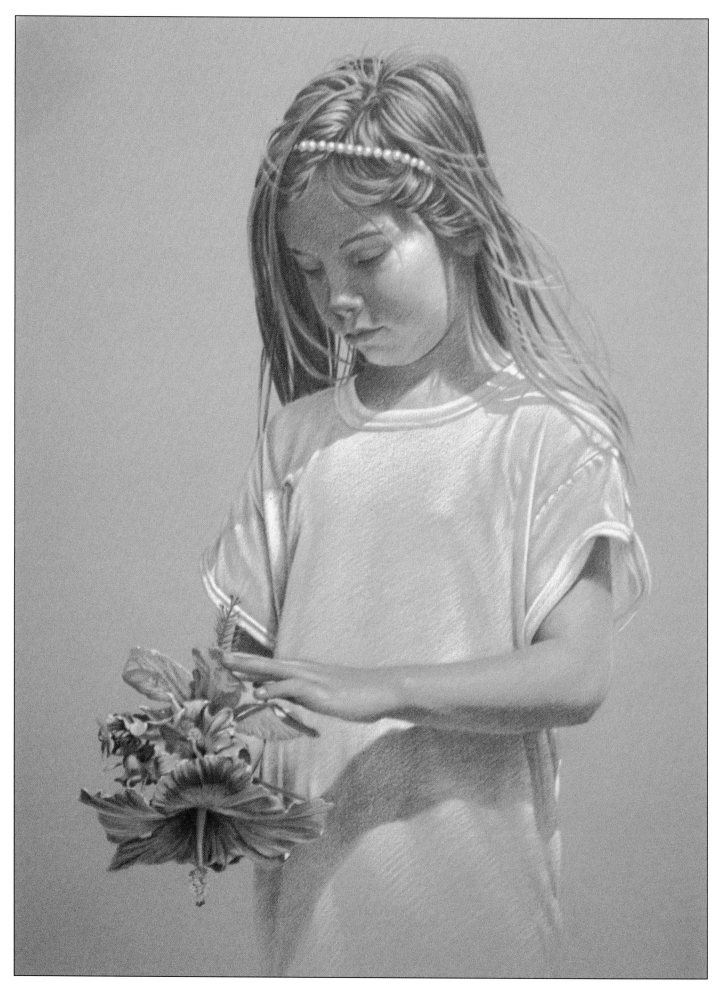

PORTRAITS AND FIGURES

MELANIE
Bernard Aime Poulin

Portraiture as an artistic pursuit is a very demanding profession. It's necessary to have an affinity with the subject that goes beyond simple visual appreciation. The artist must be aware of moods, feelings, idiosyncrasies, mannerisms, ticks, and expressions. The act of portraying is an act of social presentation: The artist is the host, presenting the subject to the viewer. Once the presentations are completed, the artist should step back and permit unhampered communication between the new "acquaintances."

If the artist needs to explain his or her interpretation, the portrait has failed to fulfill its commissioned role, even though as a drawing or painting it is successful.

Much like a surgeon, the portrait artist "cuts away" the surface and, after exploration, brings out those characteristics and individual traits that speak eloquently of the subject.

Naturally, the tools used and how they are handled directly affect the success or failure of the portrait's ability to communicate its message.

Follow the step-by-step procedures in the following portraits and see if you can determine the preliminary decisions, based on observations made by the artist prior to beginning the drawings themselves.

DEMONSTRATION
ANALOGOUS, HIGH-KEY STYLE

This portrait of Philippe is done in an analogous, high-key style. *Analogous* means that the colors chosen are in harmony with each other. *High key* means that the applied colors are bright and fresh and the only dark tones are those that enhance the brightness. In this particular work the colors are used to contrast with the mood of the portrait, which is introspective and low key. The numbers used to describe the colors refer to the Berol Prismacolor line of pencils.

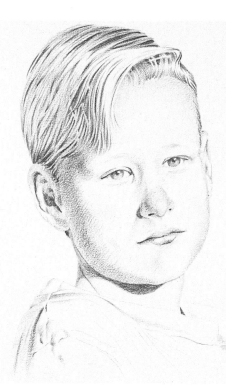

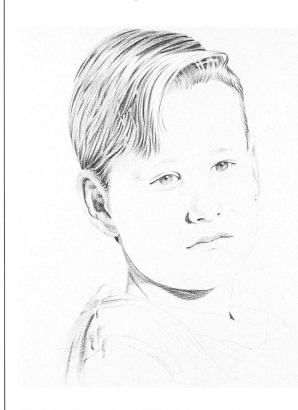

Step One: (Left.) Using a #945 sienna brown pencil with a sharp point, I indicated the high points of the portrait: Philippe's hair and his eyes. I then established the darkest darks in the hair by following its flow from back to front. Heavy pressure was applied to those areas that needed depth. Shadows were then established and the eyes were further defined.

Step Two: (Above.) This step involved refining the shadow areas leading from the eye down to the jaw, as well as the nose and eye sockets. This step either makes or breaks the drawing. It establishes the values that form the base for all future applications of color.

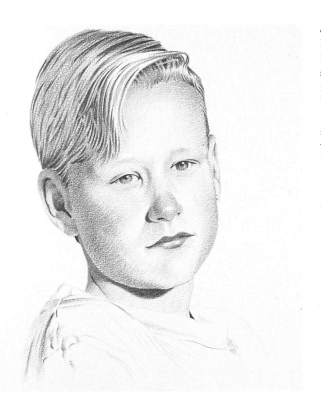

Step Three: Except for the cowlick wave, a light, even tonal layer of #942 yellow ochre was applied to the whole head and neck. This gives the portrait its bright glow. I then intensified the shadows of the cheeks, nose, and back of the neck with #921 vermillion and applied #939 flesh in a medium-pressure tonal layer to the ear. When used to overlay shadow areas, this color always gives a luminous quality to areas of skin that are more translucent. A light layer of #941 raw umber was applied to the iris and a light-to-heavy tonal application of #921 vermillion was applied to the lips.

PHILIPPE
Bernard Aime Poulin

Reflected light was indicated on the edges of the left side of the head with #942 yellow ochre. The end of the nose also received a medium layer of yellow ochre. I reemphasized the cheeks, nose, and lips with #921 vermillion and used #918 orange to add warmth to the ends of the strands of hair that form the wave and top of the head. To complete the drawing, I used a warm #947 brown to deepen and intensify the stare into space.

WATERCOLOR AND COLORED PENCIL

My daughter's good friend Blandie has an aura of sophisticated innocence about her. She is as warm and gentle a young person as she is beautiful to see. The woven background was chosen to contrast with her quiet presence. As I am fond of the rich colors found in traditional batik patterns, I sometimes use watercolor backgrounds in this way. This experiment was enjoyable. Blandie's personality, blue-black hair, and complexion are well suited to strong backgrounds.

It is evident by my choice of hues for Blandie's coloring that I reject the idea of specific rules concerning skin tones. Other than local hue, the color of skin depends more on the ambient light than on any other factor.

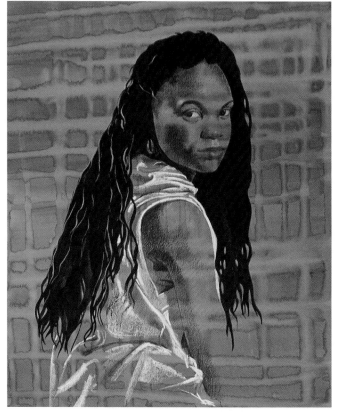

Step One: Over an almost dry layer of purple watercolor, I dripped further purple applications, both horizontally and vertically. The damp paper sponged the edges of the drips and gave the whole field a look of a batik pattern. Once the surface was dry, I sketched a line drawing of Blandie's head and shoulders.

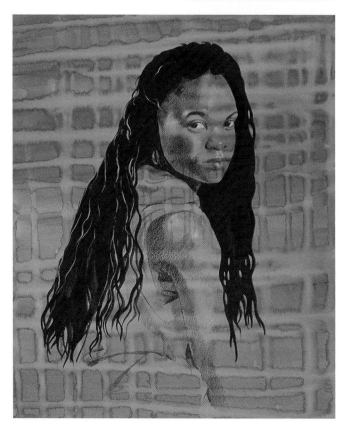

Step Two: (Left.) I then applied a deep layer of indigo watercolor to create the impact of Blandie's blue-black hair. My next step was to establish the tonal values of Blandie's features. For this I used indigo blue. Since the midtone was already established through the background, I added highlights using a white pencil. Using ice blue highlights, I gave her hair its undulating texture. Tuscan red then was overlaid on the indigo shadow areas, eyes, and mouth.

Step Three: (Above.) Blandie's forehead, cheek, chin, lips, and nose were tinted with vermillion. The girl's sweater then was highlighted to complete the frame around her head. Some golden ochre was layered on the forehead just above the arched eyebrows.

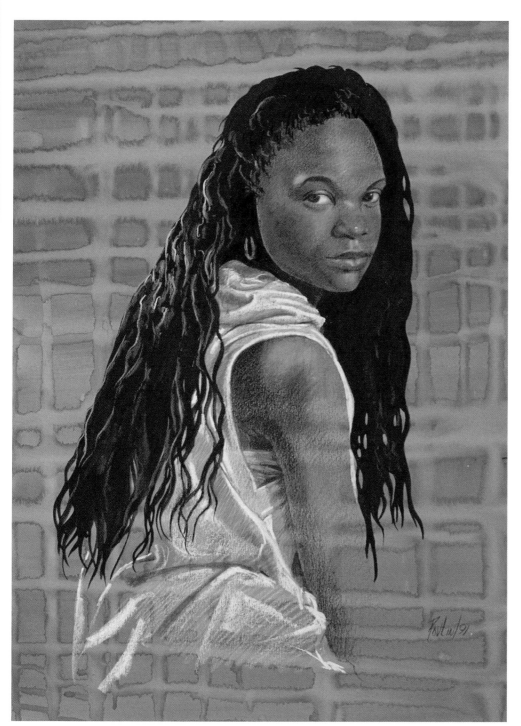

BLANDIE
Bernard Aime Poulin

To complete the complexion, I blended two colors: orange and flesh. This added a golden glow to all the facial features, as well as to the arm. A very light cool gray was applied using curled strokes, indicating medium highlights in the hair. I then burnished light flesh and added vermillion accents to the lower lip. In the shadow area behind Blandie's arm, I added heavy strokes of slate gray and blue to make the sweater recede a bit.

WATERCOLOR AND COLORED PENCIL

My good friend and godson James posed for this portrait. We agreed that he would not smile, which was difficult for him since he is rarely without one.

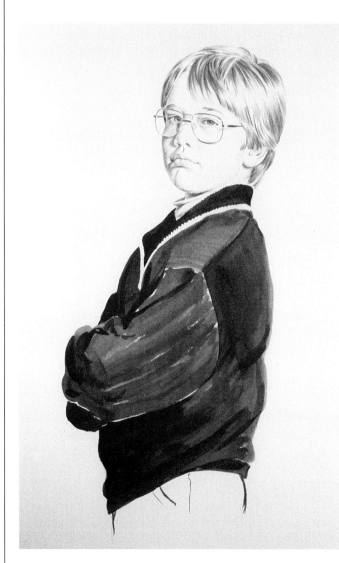

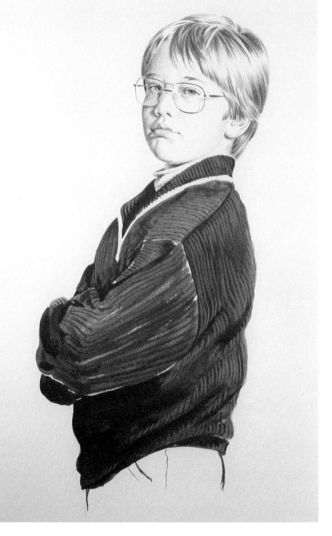

Step One: The first step involved establishing the tonal values in the hair and facial features. This is called laying in a grisaille. James's eyes and hair are very strong features that had to be carefully rendered. James's hair is a ruddy golden hue and needed to have the highlight areas well indicated. His gray-blue eyes were rendered with light tonal applications of indigo to ensure depth once further colors were added. Then, a watercolor wash of indigo was applied to indicate the sweater.

Step Two: An overlay of tuscan red was used to repeat all of the established values. This completed the grisaille, assuring me that I had achieved the feeling I wanted to convey in the final portrait. To accent the sweater's texture, I added long medium-pressure strokes of indigo to the light wash on the sleeve. A similar light application of sky blue was added to the darker wash at the back of the sweater. A light layer of terra cotta was then applied to the right side of James's hair.

Step Three: Using an ochre pencil, I lightly overlaid all of James's hair, including the highlight areas. A vermillion tonal layer was applied to the shadow area of the face and lips. Lemon yellow, with heavy pressure, was applied to the collar trim. Highlights on the dark sweater and shadows on the turtleneck were added using medium applications of slate gray.

JAMES
Bernard Aime Poulin

To complete the portrait, I re-emphasized James's hair with the same terra cotta and ochre, leaving the highlights as they were. To deepen the luminous quality of the shadow area, I added a layer of vermillion and an overlay of flesh. Repeated on the shadow side of the nose, this application heightened the intensity of the highlight. Highlights on the glasses and lower lip were lightly burnished with white. The last strokes were reserved for the eyes, the blue-gray I know well.

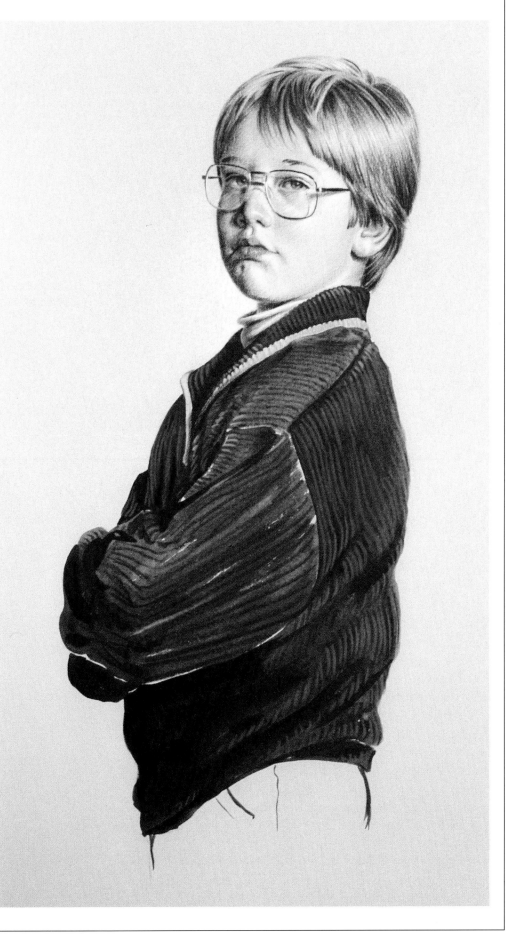

PORTRAIT PROBLEMS AND SOLUTIONS

The cutout look: One of the greatest problems in portraiture is the cutout look a subject has when it just doesn't seem to be part of the surrounding background. The following rules of thumb will help you achieve a solid, yet integrated portrait subject:

- Eliminate excessive details on the shadow side of a subject.
- Make sure the receding planes on the shadow side also integrate cool colors that lead the shape towards the background.
- The crispness or softness of edges must be considered. If the background values are closer to the lighter area values on the subject, the edges should be softened and at times blended together. The shadow side should blend. Dark edges meeting light edges and light meeting dark should alternately have a "crisper" feel.
- The reverse is true as well: dark edges meeting dark edges and light meeting light should blend.

The point is to establish a balance between integrating the subject into the background and at the same time giving the subject its own solid and dimensional form in space.

Observe the following portraits and see if you can determine the preliminary decisions, based on observations made by the artist prior to beginning the drawings. Notice how the artist went about solving the problem of placing the subject in the background.

Hair color: Blond is not! Neither is black, black nor brown, brown. Depending on the light source, hair color will vary dramatically. Under a blue sky, blond hair may have tinges of ochre, olive, and ice blue in it. Under incandescent light, more reds and rusty browns will integrate with the local color. Under a cloudy or hazy sky, blond hair will exude wisps of cool grays.

Black hair under open skies will invariably show highlights of rich sky blue and steel gray. Brown hair ranges from almost black to sandy blond. Ambient light always affects the color of an object within the rays of its own particular light. It is therefore always necessary to study the shades that become integrated with the basic color of that object.

In colored pencil drawing, as in any other medium, the artist must eliminate his or her intellectual, logical approach to see and focus on rendering what the eyes

"say" is there, even if it feels strange at first.

Drawing hair: A head of hair may be the aspect that either makes or breaks a portrait. We simply "know" too much about hair. We are fascinated by its color, its thickness (or its scarcity!), its properties, and its styling possibilities. But most of all, we are intrigued by the sheer number of hairs on our head.

This academic and cosmetic approach to hair is the reason we fail to render it with ease and give it its fluid, flowing "visual" qualities.

The following demonstration, as well as the previous ones in this chapter, should help you see these principles in action.

DEMONSTRATION
HAIR

Step One, Mass: (Above.) Establish the main mass framing the face and covering the head. Ignore the flow of hair, the numbers, and the thickness and concentrate just on establishing the shape of the tonal mass.

Step Two, Smaller Masses: After establishing the overall shape, squint at the subject. This eliminates details and helps you see the smaller masses that define the directions in which groups of hair flow. Render each dark shape first, comparing each to the others by size, value, and form. Apply tonal applications with strokes in the direction the hair falls. Then, delineate middle tone areas and highlight shapes. Ignore individual hairs completely.

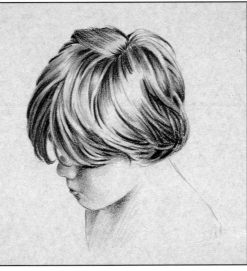

Step Three, Values: Apply strokes that follow the direction of each small mass of hair. The strokes do not define individual hairs, but concentrate on direction and the play of light and shadow. This step is the most important. It establishes the values that give life to the mass of hair. Once this is done, a tonal layer of local color (blond, brown, etc.) is applied everywhere except highlight areas.

JOHNNY
Bernard Aime Poulin

(Left.) The warmth of his family and the independence they encourage are both evident in Johnny and are indicated through the use of hard- and soft-edge techniques. The light behind Johnny's head separates him from the background, making him "his own man." Yet his unity with his family (unity with his "background") is shown by the almost complete integration of the sport jacket with the tinted drawing surface.

Step Four, Color: Over the tonal application of local color, each clump of hair is redefined and heightened in dimension through direction-oriented applications of the various colors perceived by the artist's eye. Use heavy to light strokes to intensify the darks and midtones. Through keen observation, note whether warm or cool color must be applied. Remember, the ambient or atmospheric light plays an important part in establishing which colors to use.

CHILDREN'S PORTRAITS

It's impossible to render the portrait of a child or to use children as models if there is no tangible respect, admiration, and communication between the artist and the subject. A sizable book would be necessary to convey all that should be taken into account when dealing with children as subjects or as models. Nonetheless, I will try to summarize in a few lines the situation of an artist "confronting" a child as model.

Children are not fools and do not suffer fools gladly. It's very difficult to pretend to like them, because their capacity to read the hearts and souls of adults is awe inspiring. I owe my success in child portraiture not only to many years of anatomical study and an understanding of the psychology of children, but also in great measure to my appreciation for the incredible capacity of children to savor life to the fullest. Their free expressions of curiosity, their insatiable need to discover and learn, and their vitality and resilience have always made them my favorite subjects.

Picasso, Cassat, Peel, Raphael, Velasquez, Murillo, Manet, and Gainsborough, among many other Masters, all discovered the wonder and grandeur of children. Achieving this state of heart and mind regarding the child is not learned. It's something within the artist that needs to be expressed in the most eloquent fashion. Some artists feel the same about trees, the ocean, or the sky. It's not a melodramatic or melancholic feeling. It goes beyond the "cuteness" of children and reaches the essence of each individual child as a person in his or her own right.

Reticence: Children are not easily fooled by white-toothed adult smiles enticing them to do something they are unaccustomed to. Deliberate shyness, obstinate resignation, elastic "I want to please you" grins, or open hostility may be displayed when a child is asked to sit for a portrait. None of these is the real child.

A professional artist must take the time that it takes to get to know the subject. At times, adults find children so cute they forget to consider the individual be-

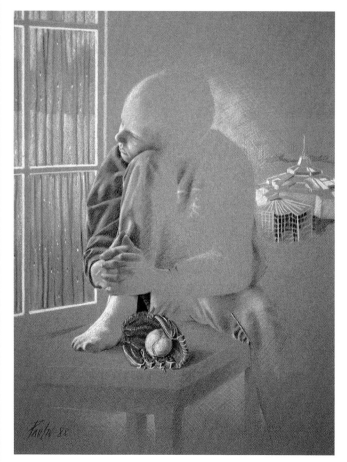

WAITING OUT THE STORM
Bernard Aime Poulin

(Left.) Ryan, the model for this drawing, had cancer. Despite his illness, he agreed to help me create this drawing to heighten public awareness that cancer does affect children and to raise funds for the new cancer unit being built in his hometown. Today Ryan is healthy, active, and a shining example of courage and tenacity.

STRIPES
Bernard Aime Poulin

(Above.) *Stripes* is basically the result of a great recipe. The ingredients are Greg, a consistently fantastic model, and an old striped sheet. The combination of flowing stripes and wavy hair softly masks the complexity behind the model's powerful gaze. Chosen for the cover of the March, 1988 issue of *The Artist's Magazine*, this drawing is based on simplicity and direct focus.

neath the cute exterior. This is always a fatal mistake. Just as we study trees, the wash effect of waves, and the gradated blues and grays of a sky, we also must take the time to study children.

A child subject must be given the time to become acquainted and comfortable with the artist. Some children will need more time than others. On the other hand, the artist should seize this opportunity to observe and to gather information that will make the portrait more lifelike and unique.

Involving the child in the process, including the choosing of clothes, accessories, and props, is a sure way of gaining his or her confidence. The last step is usually the most difficult: Getting rid of the parents! Parents' generous and exuberant "help" is often the main obstacle to the realization of a successful portrait.

Child models: I have created many book covers, illustrations, and posters using children as the main subject matter. Most of my models live in the vicinity of our home and studio or have been discovered quite unex-

pectedly during everyday outings to the store, church, or school. I have somewhere between ten and twenty children on file at any given time. They range in age from five to fourteen. My complete list of models reaches the age of eighty-three. Some adults often qualify as models because they are, by their very nature, still so in love with life and exude childlike qualities necessary for posing.

Working with a child model is more complex than using adult models. This is not to say that the situation is more problematic. Children enjoy being involved in the idea behind the work to be created. They love to playact and are more enthralled with modeling if they understand what the artist is trying to convey. Children also can tell the artist whether a specific expression, behavior, or pose is appropriate to their age group. They are not phonies and hate to be so. Honesty with children is always the best policy.

Hairstyles: Unless you are looking for a specifically contemporary feel to your artwork, it is best to choose

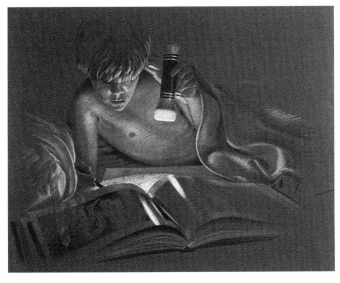

SELF-TAUGHT ARTIST
Bernard Aime Poulin

This drawing was created as a nostalgia piece. It describes my own determination, despite the odds, to learn the rudiments of drawing and anatomy. By the age of eight, I wanted to be a portrait artist. At ten I was still determined. The biggest obstacle was my inability to draw the human

form well. Because adults could not understand this young boy's legitimate interest in the body, I resigned myself to sketching nudes by flashlight. The secret is now out and I have since inherited the encyclopedia from which I studied and sketched the ancient Greek and Roman statuary.

REALLY!
Bernard Aime Poulin

Whereas most boys enjoy the rambunctious activity of a gang, little girls often prefer the company of just one special friend. I have had many years to observe our two daughters and their friends, many of whom have

modeled for drawings based on my observation of their behavior. This drawing recalls those intimate times of shared secrets between best friends. My daughter Valerie and her friend Isis modeled for this monochrome sketch.

child models whose hairstyles are generic in the sense that they might be appropriate for both 1935 and 1992. A very natural not-too-short, not-too-long look is usually best for creating a work of art that is universal and timeless in its appeal. Boys are less reticent to become models when they discover that the artist will usually be the one to decide when they need a haircut! I even have gone to the barber with one of my best models to make sure the stylist didn't ruin a great head of hair.

The following examples of portrait and figurative work by various artists will explain the blend of vision, empathy, and technical expertise necessary for successful figurative representations.

PIONEER AVIATOR
Ken Raney

High Key 1: I immediately fell in love with this drawing of Ken's. The brilliance of this very simple presentation lies in the high-key approach that speaks so eloquently of the bravura and high expectations of this proud breed of visionaries. They wanted to fly—and they did. The luminous quality of the light color applications on a warm drawing surface heightens the mood and elevates the mere man to a more than mortal being.

JIMMY
Bernard Aime Poulin

High Key 2: (Right.) The self-assured pose and look in this young man's eyes belie the fact that there is still a lot of the boy in the man. The high-key approach was used to counterbalance the strong direct gaze and pose. Lighter colors in the clothing tone down the mood and make us aware that Jimmy is his own man, but also an okay person.

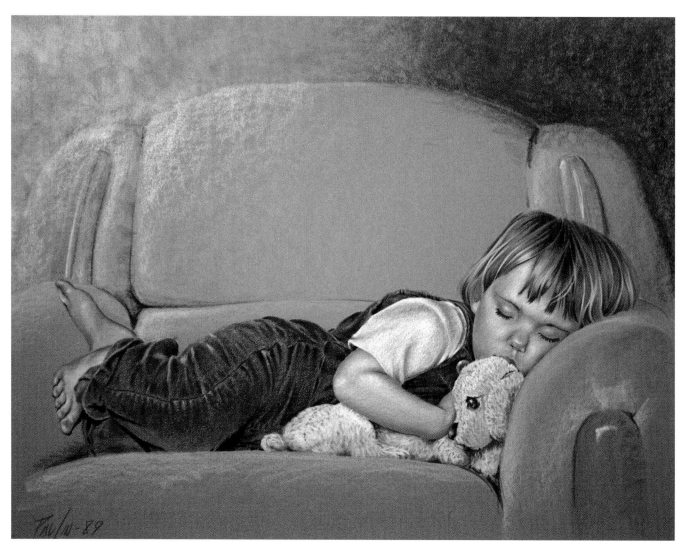

SLEEPING CHILD
Bernard Aime Poulin

Low Key: The low-key approach of this drawing was necessary to express the mood of calm and peaceful slumber. Grayed colors tend to relax and bring out the softened reactions to such a scene. Bright colors would have created disturbing "noise," making the drawing too loud to be reminiscent of calm and safe rest.

In the composition of this drawing, all edges have been softened and corners rounded. The womblike softness of the chair is still massive, connoting strength and reassurance. The rounded shapes add to the mood.

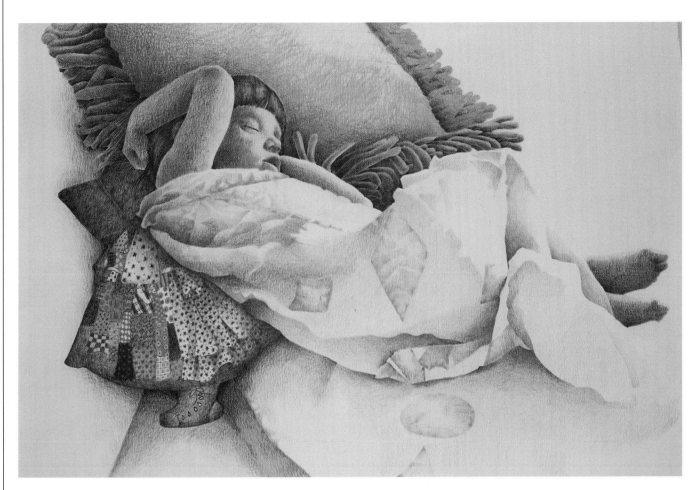

AFTERNOON NAP
Suzanne Rusconi Accetta

High Key 3: In contrast to the low-key presentation of my *Sleeping Child*, Suzanne's *Afternoon Nap* is valid despite the fact that she has chosen a high-key approach. Her rendition of a child's nap is in keeping with the glow emanating from a parent's warm onlooking. A "stop and smell the roses" feeling is present here. The unsaturated colors on the stark white background create a feeling of imminent awakening, and the child should feel safe in awakening into a bright world in which uninhibited pleasure at being alive can be expressed.

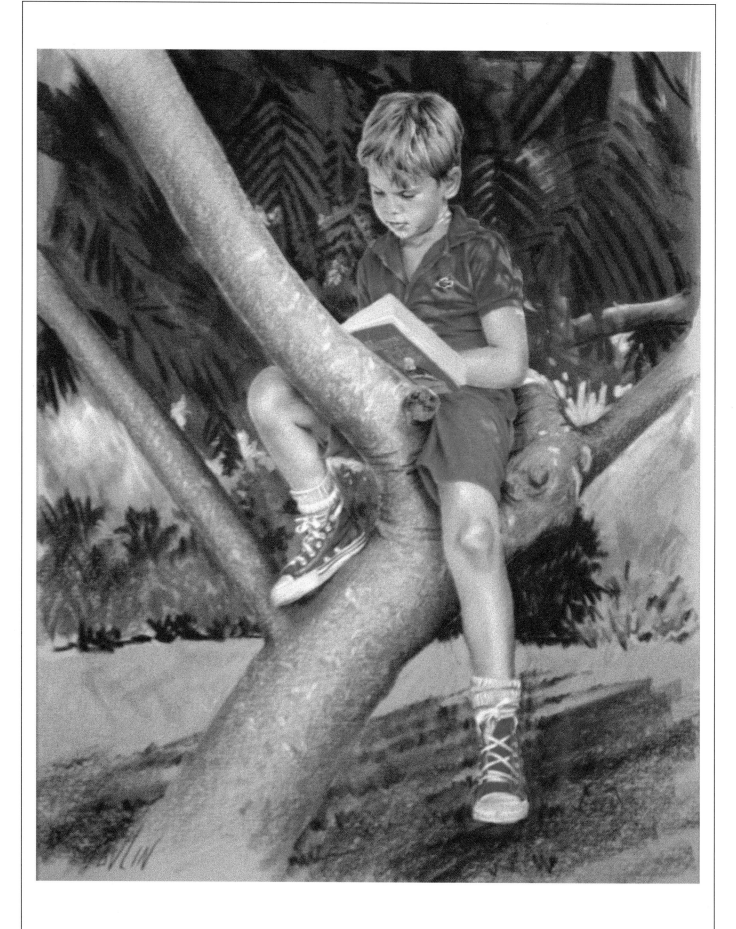

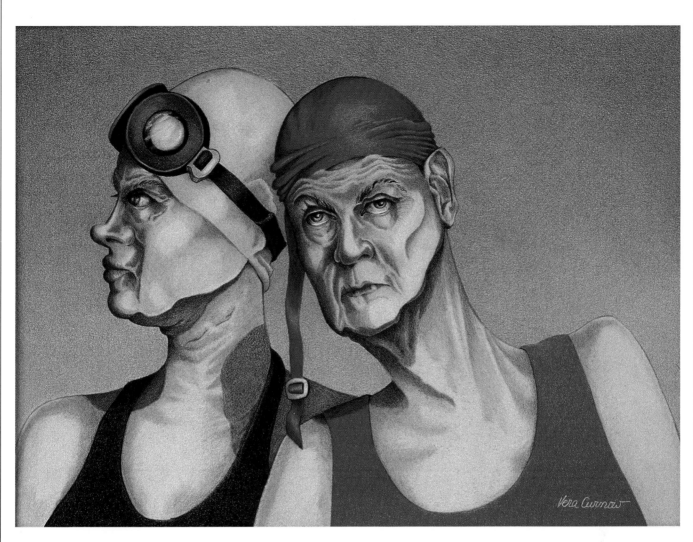

DAVID
Bernard Aime Poulin

Personality: It's difficult to present a child's personality if the pose is stiff and formal. David is a self-assured individual whose active life-style comfortably encompasses intellectual and adventurous pursuits. He hasn't the time to stop and rest. Even the reading of a good book can be intertwined with climbing a tree or doing wheelies on his bike. (He wears a helmet, of course!) This watercolor-and-pencil portrait speaks of who the sitter is, rather than of who the artist wants him to be. When a person is posing for a portrait, it's vital to consider this distinction if the portrait is to be successful.

LIFE'S A BEACH
Vera Curnow

Whimsy and Figures: Viewing Vera's drawings of the ordinary flesh-and-blood person in all of us, coupled with her so apropos titles, is a wonderfully enjoyable experience. Her interpretations of our foibles and physical presence have a tendency to ground even the most haughty of us. As amusing as the final product is, Vera's work is serious and professionally rendered. She has so much to say in her exquisitely layered blends and tonal applications, and her colors are vibrant and dimensional. The applications of color are most times on the verge of total saturation, yet the drawing surfaces always retain a sparkle of luminous force. The overall impact in Vera's work always is one of empathy for the subject, coupled with a humorous look at the idiosyncratic human.

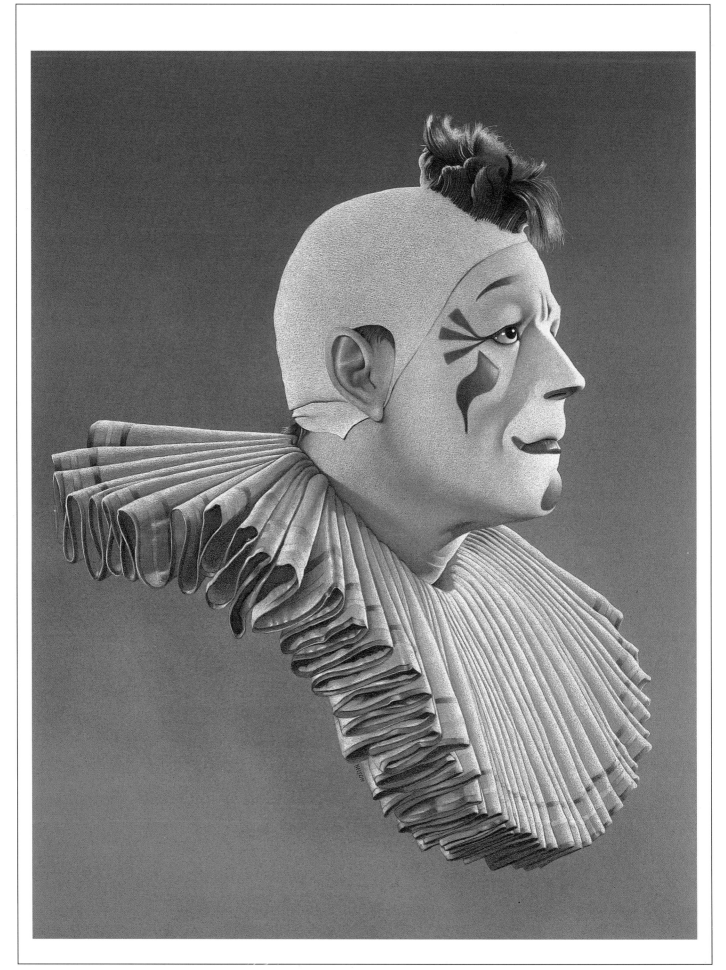

CLOWN
Bill Nelson

Degrees of White: (Left.) White can either make or break a drawing. Bill's *Clown* merits close scrutiny. His various, yet subtle uses of white are an important factor in the success of this piece. Combining his gradated tonal applications of white with the midtone color of the background, Bill achieves a rarely seen luminous vitality. The artist's range of controlled pressures is exceptional. The clown's head, though white, is rendered with subtle gradations of white, matching the intensity of the highlighted face only at the back edges and top of the head. The highest degree of saturated white in the eye's highlights gives this portrait its emotional focal point. The stirring power of the faraway look is the result of total saturation and the lack of competition with other whites of the same intensity.

AIN'T MISBEHAVIN'
Bill Nelson

Drawing Surface Midtones: This fine illustrator knows how to make the most dramatic use of lighting. He is aware of all the nuances in the luminous richness of his shadow areas and knows more than enough about the importance of retaining midtone backgrounds in his color applications. Never completely saturated, Bill's colors always integrate the background tint. This fact alone is the solid foundation upon which lies the total coherence found in his illustrations. Those of us who wear the title "fine artists" would do well to study illustrations of this ilk.

LANDSCAPES

FERNDALE BIRD HOUSE
Karen Anne Klein

The same landscape seen by different artists will convey different feelings and emotions. How artists look at a subject is always very personal. A landscape to one person may be interpreted as a luscious combination of cooperative shapes, light, and contours. To another, every detail speaks of the complexity and grandeur of nature. Some artists, like Don Pearson, seem to love the wide expanses of majesty and unspoiled peacefulness of wild countrysides. Others prefer searching out the secret or hidden aspects in the obvious. Landscapes can be grand and open, or they can be as limited as a few inches of open-air space.

How you perceive your environment is very personal, but how you choose to capture it on paper depends heavily on the techniques used, the planning you have given the matter, and the perspective from which you choose to render it.

Interpreting a landscape is a matter of point of view, both physically and emotionally. A successful attempt at landscape drawing involves a combination of personal feelings and the choice and handling of materials used to translate the mood to the viewer.

Whenever I sketch on-site, I always bring along a dozen tinted, acid-free boards, usually leftover scraps of matboards from the studio. These are cut to approximately twelve inches by fourteen inches to fit snuggly into an old portfolio bag.

DEMONSTRATION

CAPTURING THE DAWN

On my last canoe trip to Algonquin Provincial Park, over an early-morning campfire coffee, I couldn't resist the dawn mist and its serene lightness floating on the water before me. Instinctively, I knew I would have little time to capture the light that made the whole scene sparkle. In a flash, I grabbed a rusty-red-tinted board, my pencils, and colored sticks.

Working on-site often is hampered by changes in light, shadow intensity, and patterns, even as you lay out the initial composition. The following step-by-step sample will show how I was able to capture and "hold" the light and shade patterns before they were altered by the rising sun.

Step One, Laying in the Shapes: To capture the elusive patterns of light and shade, I quickly shaped the nearest mountain and its reflection in tonal layers, using the length of a dark green colored stick. This established my darkest values immediately. With an aquamarine colored stick, I laid in the foundation for the darkest area of the sky and the horizon line created by the slowly rising mist on the water. Above the mist to the left, I indicated the brightly lit far shore with one sweep of a green bice colored stick. A cream colored stick was used to give the bright sky its lightest value. In three minutes, all the information I needed to retain my first impression of this morning was down on the board. Looking up, I saw that the light had already changed drastically.

Step Two: The ever-rising sun causes new brightness and intricate details to emerge in the mountain landscape. I am forced to hark back to my initial impression of the scene. I must be careful not to fall into the trap of dulling the sharp contrasts or adding distracting details. Therefore, I continue applying color with the sticks, intensifying both the darks and lights by reworking the large masses with heavier applications of the same colors used in Step One. I then overlay the blue mist and the orange reflection with cream. With heavy strokes on the end of the green bice colored stick, I also scribble abstract trees on the far shore.

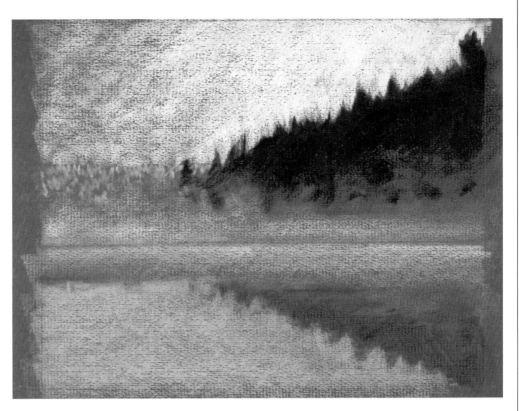

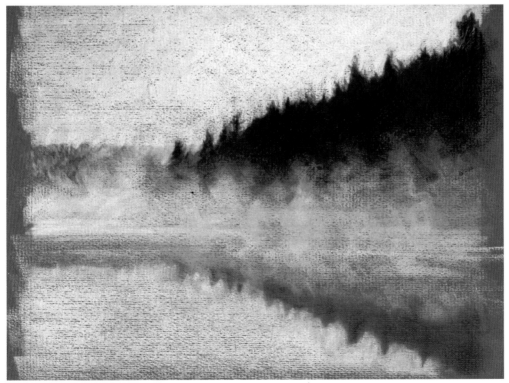

ALGONQUIN PARK
Bernard Aime Poulin

Step Three: To complete this sketch, I continued the process of intensifying the lights and darks with the same limited number of colors, until the contrast was just what I had remembered. To give the dark mountain a richer color and texture, I overlaid a heavy application of purple with colored sticks. Once all my tonal values were judged appropriate to my first impression of the landscape, I gave the sky and reflections and mist a burnishing of cream.

During this exercise, the rust-tinted drawing surface glowed through, warming the whole dawn landscape. The red glow reminded me of the old saying: Red sky at night . . . sailor's delight. Red sky at morning . . . sailor take warning. (It poured rain not three hours later!)

OTHER LANDSCAPES

The following group of landscape interpretations are very different from each other, but they all have one thing in common: the choice of tools and their handling speak eloquently of each artist's vision. I hope that you will enjoy studying the various details that make these drawings successful. By observing them carefully, you will gain insight into your own perceptions and feelings about landscape drawings.

HOW GREEN IS THE CORN
Allan Servoss

Simplicity: To create a clean, simple drawing of a landscape seems easy. It is not. To achieve this moody landscape, Allan had to be aware of the factors that would make this rendering work: the low-key choice of colors, a triadic complementary palette of unsaturated purple, green, and orange; and simplicity of form and composition. Add to this a horizontal composition and together these elements create a very successful mood of disquiet, rather than calm.

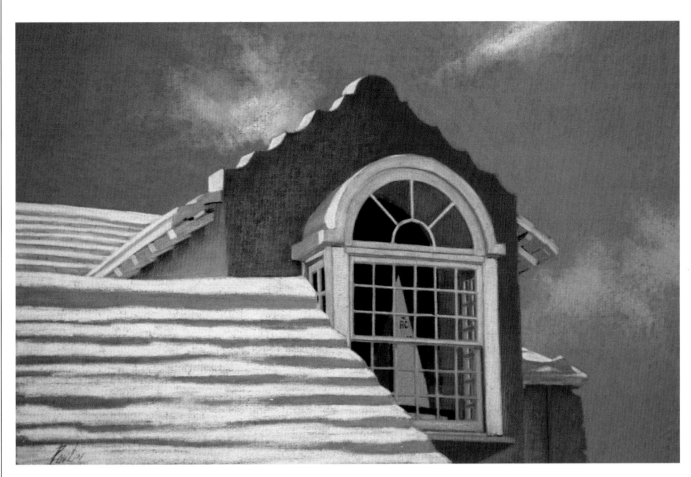

STEVAN'S WINDOW
Bernard Aime Poulin

Light: A landscape perspective is a matter of point of view. My landscapes always tend to pinpoint an element in my field of vision, rather than give a wide-angled perspective. Stevan's window has fascinated me for years because of its architectural design and the sailboat on the sill. To unify the whole composition, I chose a deep burgundy board as a drawing surface. Despite the heavy applications of saturated colors using colored sticks, the drawing surface still peeks through the applied colors. The bright blue Bermuda sky and the architectural subtleties of this beautiful old home still fascinate me after more than twenty years of flying into this beautiful island.

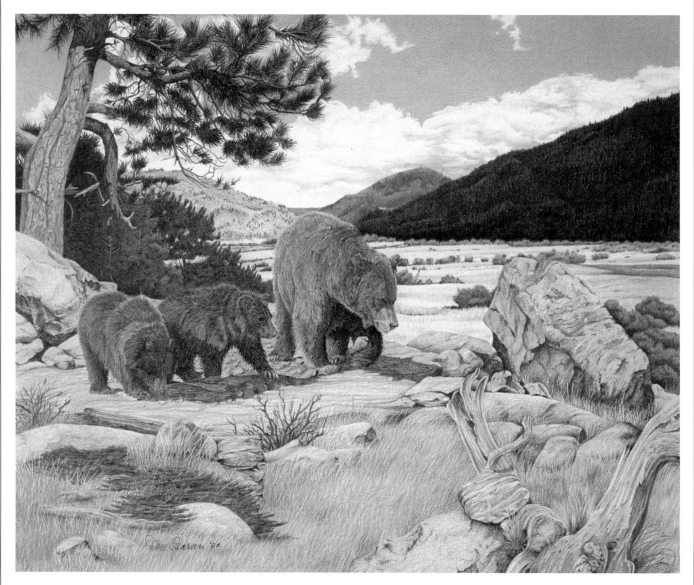

GRIZZLIES
Don Pearson

Detail: Don Pearson is one of the few artists I know who convincingly evokes the image of sap running through the greens of his foliage and needles. This is the result of knowing what lies beneath the rich greens of plant life. The application of a complementary red prior to the overlay of green always gives life to the flatness of a single green application. Note also the atmospheric blue-green of the hill in the distance. This work is also a fine example of the application of the most basic strokes in colored pencil. Expertise is shown in the beautiful lay of short- and medium-length strokes, both in the shaggy coats of the bears and in the ochre grasses. Don is a great believer in the slow buildup of colors, rather than in the use of heavy applications. His results prove that you don't need to rely on tricks or techniques to create successful artwork.

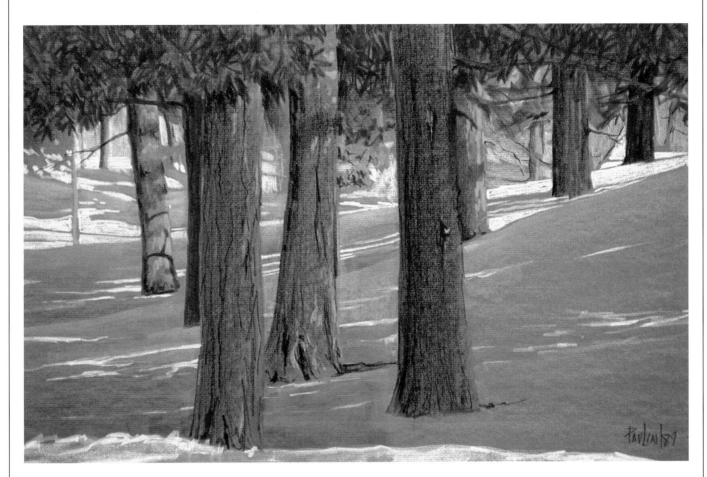

GATINEAU WINTER
Bernard Aime Poulin

Winter: Gatineau Park winters are usually beautiful and quiet. The old trees seem to be keeping the peace. This is the first drawing I ever produced with colored sticks exclusively. I used every edge and side of the sticks. The foliage was rendered with short, jagged strokes. The trees are a combination of light tonal applications on the warm purple board and irregular long strokes to indicate the age and definition of the trees. The expanses of shadowed snow were produced with long sweeps of colored sticks in the warm-purple to cool-blue range. The highlights on the trees are sand and aqua. The bright snow areas were created with heavy pressure on white and light flesh colored sticks.

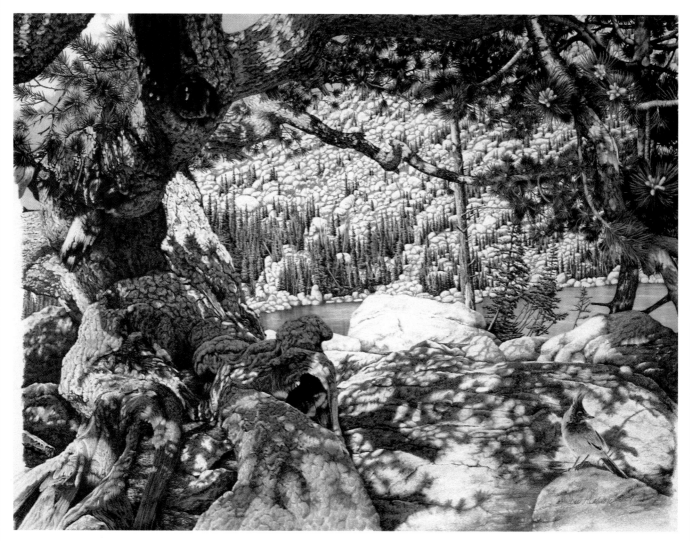

AT LAKE HAIYAHA
Don Pearson

Texture: It's a challenge to fill a picture with textures and yet not lose the picture. Don builds up his color slowly, paying attention to every stroke. He also is always building the broad design of his drawing, not concentrating on the trees at the expense of the forest. You can see this in the way he developed a dark arch that goes up the tree trunk and around the pine needles to help structure the wonderful textures.

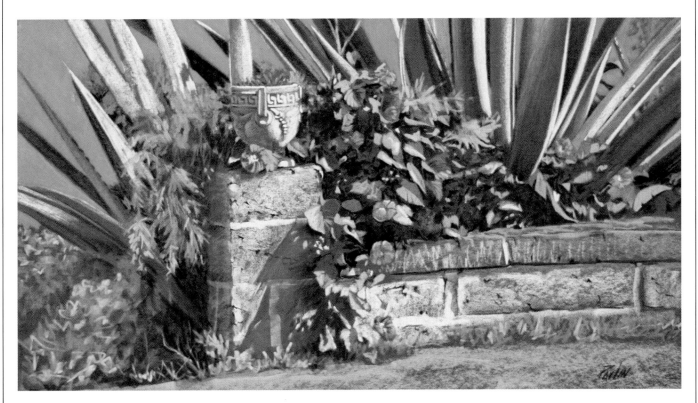

GARDEN WALL
Bernard Aime Poulin

Colored Sticks: To do this drawing of the garden wall outside my kitchen window in Bermuda, I chose a rust-colored board and a combination of colored pencils and colored sticks. All of the plants and moss were built up with several layers of colored pencil. The large spikes were burnished once I had captured all of the colors this plant had absorbed from the surrounding area. The wall itself was left to the last minute, since I knew that I would be creating it with quick, medium-pressure strokes with the sides of half a light flesh colored stick. The texture of the board created the rough stone texture on its own; all I had to do was add the final small details of cracks and fissures. The rust coming up through the grass is reminiscent of the color of the Bermudan soil.

SHAKERTOWN GATE
Ken Raney

Luminosity: I immediately fell in love with Ken's "landscape still life." The luminous quality he achieves through soft-edged and unsaturated color applications for the background entices the eye to focus directly on the crisp-edged gate with its subtle hints of age. As in Bill Nelson's *Clown,* the limited and specific use of totally saturated white highlights and intensifies the feeling of warmth and intimacy.

FLOATING
Allan Servoss

Crispness: This bird's-eye view of a winter landscape is another of Allan Servoss's pure simplicity landscapes. The crisp air is accented through hard edges and the quiet soaring sound of flying. The gradated tonal layers radiating from the top right and from the shadow at the bottom left convey a feeling of defined space. The flying viewer is definitely eavesdropping on a specific rural area. The quiet stillness created by the unsaturated use of complementary colors enhances the mystical qualities of this scene. You almost expect someone to come out and shovel a path to the edges of this world.

CONCLUSION

What lies beyond hatch and crosshatch? Where do you go after you have assimilated the necessary skills of colored pencil drawing? I believe in one sense an artist is always a "beginner": someone who constantly returns to the "roots" in order to discover more.

My work—your work—needs to be constantly challenged if it is to grow in quality. New methods and uses will always be discovered, and new teachers and books will bring this information to us. Ultimately, you will know enough to begin breaking the rules, to begin experimenting with the knowledge you have and the new materials you encounter.

If *The Complete Colored Pencil Book* encourages this process, then I will be satisfied it has nurtured and encouraged your love for colored pencils and their infinite capacity to awe.

UNTITLED, Bill Nelson

INDEX